SKETCH APPEAL ♡

THE ART OF SELF-LOVE

Sketch & express yourself like never before!

DULCIE BALL

Hardie Grant

B O O K S

DRAW YOUR OWN COVER

Put your stamp on it – this book is
dedicated to YOU! Create your own
cover design on the page opposite,
then show and tell us all about it on
Instagram **@sketchappeal**!

CONTENTS

PREFACE

DRAWING IS A LANGUAGE THAT WE CAN ALL SPEAK, AND PENCILS ARE TOOLS THAT WE CAN ALL USE TO MEDITATE, EXPLORE AND EXPRESS OURSELVES.

This book is not about getting better at drawing – it's about using your creativity and mental strength to get better at LIFE! The aim isn't to teach you 'how to draw' or master the art of self-portraiture, though naturally the more you draw the more confident in your ability you'll become. The challenges in this book are simply playful invitations for you to spend some time reflecting, exploring and expressing yourself creatively, in order to nurture and reconnect with your true self.

You might find some of the prompts trickier than others, and some might challenge you both creatively and emotionally. But stick with it and BE KIND TO YOURSELF – you can't get any of it 'wrong'. Remember that even Picasso had his off days! This isn't an endurance test or an art exam, and there's no-one judging you or grading your efforts; so just take it at your own pace and enjoy the PLAYTIME!

It's time to mute your inner critic, silence your smartphone and switch your creativity ON!

INTRODUCTION

HEY YOU!

I'm Dulcie and I'll be cheerleading you along the way as you read and SMASH each challenge in this book! I LOVE drawing and think we can all benefit from doing it more, so I'm thrilled to be guiding you on this exciting 'art-venture' in self-discovery and self-expression!

I'm not a professionally trained artist or teacher, so I won't be offering up any technical drawing tips. I'll simply provide you with some playful creative prompts and self-care tools that I've found to be fun and beneficial to my own mental health.

As well as a few of my own portraits and illustrations, you'll also find plenty of inspiration from some of the amazing artists who have empowered my creative journey over the past few years: artists who like me, openly acknowledge and advocate the healing powers of drawing and making art. Collectively, I hope we ignite your creative confidence and entice you to spend some quality time sketching, reflecting and expressing yourself like never before!

LOVE,

Dulcie xx

MY STORY

They always say to 'write what you know', so at this point I feel compelled to share my story with you. After all, this book is about exploring and expressing your inner truth. Ultimately, the ideas within these pages have come to light as a result of my own mental struggles, which without drawing, might have had a very different end. It sounds dramatic, but drawing didn't just change my life – it saved it.

Nowadays, I draw obsessively, but rewind to a few years ago, where I had a very different obsession. Back in 2016 I was a career-driven workaholic and in the middle of my third relapse into anorexia. I was close to hospitalisation and my mental health was at rock bottom. It was on a pretty fortunate whim that I decided to go along to a life drawing class with a friend.

I'll never forget that night. As soon as I started drawing I felt such a rush of joy and energy – like an electrical charge – and a connection to something that had been switched-off for so long: ME! It sounds so trite, but that night I experienced an epiphany that reignited my passion for drawing and spurred me on the road to recovery – on a creative adventure that continues to this day.

After that I was hooked. I started to draw twice a day, every day, as a form of daily meditation and self-care. I started to replace negative thoughts with creative ones: to obsess less about calories and exercise, and more about coloured pencils and felt-tip (marker) pens! I began to prioritise creative play over self-punishment, process over perfection; to spend more time hanging out with the 'inner child' I'd locked away for so many years. Gradually, the more time I spent nurturing my creativity, the more grounded in reality I began to feel. Slowly but surely, I (quite literally) drew myself back to life.

For me, drawing has been a game changer *and* a lifesaver. It has been vital to my recovery and essential to my mental health and wellbeing. Through drawing, I have found peace, joy and love in all that I am, and I have discovered the perfect antidote to my perfectionism! I still fuss and finesse in every other area of my life, but when it comes to drawing, I don't think about or care whether it's perfect or even any 'good'! I just love how it makes me feel.

MY APPROACH

The challenges in this book are based on the tried-and-tested activities and methodologies I use when running my creative wellbeing workshops. You'll find lots of self-portrait prompts, because I've found these to be a really popular and effective way to develop both confidence and imagination – so expect to get very familiar with your own face! Many of these portrait prompts were inspired by a 100-day project I began back in March 2019, when I attempted to draw 100 mini self-portraits from the same reference image, in as many different styles as possible. It may feel wildly self-indulgent to spend so much time drawing yourself, but trust me, it's a simple act of self-care and the results will last a lot longer than a manicure! I really hope you get as much out of the challenges as I have.

'THROUGH DRAWING I HAVE FOUND PEACE, JOY AND LOVE FOR ALL THAT I AM.'

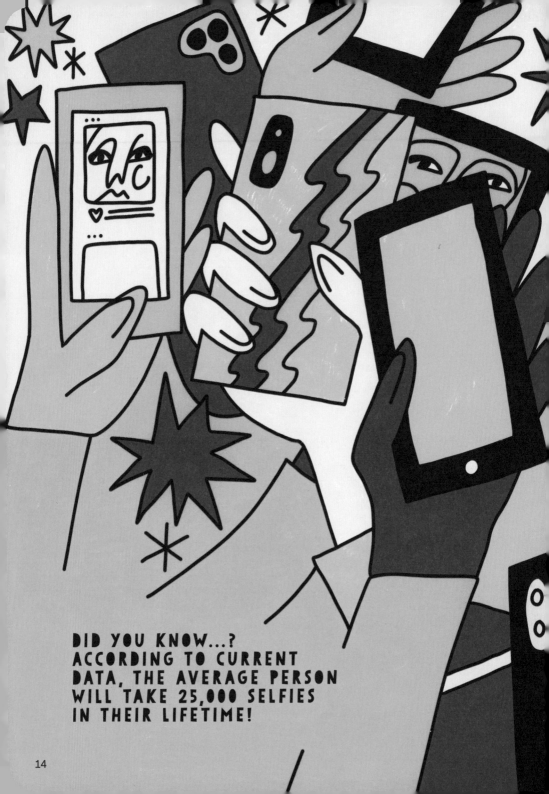

DID YOU KNOW...?
ACCORDING TO CURRENT
DATA, THE AVERAGE PERSON
WILL TAKE 25,000 SELFIES
IN THEIR LIFETIME!

THE 'ART' OF THE #SELFIE

Taking selfies can be a hugely empowering and fun experience. Taken spontaneously, they capture the joy and light-heartedness of life. Taken obsessively or repeatedly, and the game gets a little more dark. While a badass selfie can boost our confidence, an unflattering one can shoot it right down. Many of us (myself included) take and retake pictures until we're happy we've got something decent, and then delete the rest. With camera phones in our hands and a huge array of filters at our fingertips, we can manipulate our reality in any way we like. Consciously, or unconsciously, by deleting the 'bad' photos and sharing only the 'good' ones, we are all, in some way, 'faking it'.

With our reality filtered and blurred in this way, it's easy to see why so many of us are at odds with our bodies and looks. Not only do we have the pressures of social media and the beauty, diet, fitness and fashion industries on our back, we've now got our own best selfies to live up to. By capturing only the 'best', it's easy to lose sight of how we actually look IRL, and to end up frustrated when we look in the mirror. The more closely we dwell on our digital 'faceprint', the more we lose sight of what matters: not *how* we look to the world, but what we *give* to it. As humans and creators, we have so much more to offer than 25,000 selfies!

I'm fairly digitally-savvy, but I must confess I still don't fully-understand Snapchat and have only just discovered Facetune – apparently Apple's most popular app of 2017. For those of you unfamiliar with it, Facetune enables you to make 'subtle' tweaks to your face via various tuning tools, as well as apply a whole range of flattering filters. You can raise your eyebrows, recolour your skin, lift your jowls, make your pout pop...all at the push of a button. It's terrifying, and yet easy to see how a few tweaks here and there can turn into a regular 'facetuning' habit – especially if all your mates are doing it.

Digital 'facetuning' is one thing, but it's even more worrying when cosmetic surgery adverts (commercials) are thrown into the mix. Cosmetic surgery and botox are now more accessible and socially acceptable than ever. Nowadays, you can get a 'liquid nose job' quicker than you can get a full head of highlights – and for not much more money! These so-called 'tweakments' are rearing their cosmetically enhanced heads everywhere and are hitting the mark with the Insta generation, who like their thrills and fills on demand. But what the hell is all this doing to our self-esteem?

The pressure to look our best is EVERYWHERE and EVERYONE is susceptible to it. It's so hard to switch-off from the daily feed of content telling us to wear this, like that, do this, buy that, drink this, eat that, check this, share that, and above all – and at the same time – look lean, mean and flawless! Society has changed so much in my lifetime, but one thing hasn't changed: fundamentally, we are still led to believe that if we *look* a certain way, we will be more attractive, successful and loved. There may be more conversation and focus on the importance of feeling good and doing good, but looking good is still a BIG part of the mainstream happiness equation.

There's no denying that the Internet and social media have empowered us, but they are also trapping us and holding us accountable for the way we present ourselves, and every single thing that we say and do. The world is crying out for something to entice us away from this alternate reality and to reconnect us with who we *really* are. We need to find a form of self-expression that disconnects us from the grasp of social media and gives us an opportunity to discover and celebrate what makes us unique...

...AND THAT'S WHERE THIS BOOK COMES IN!

WHY SELF-PORTRAITS?

Ask any adult about the last time they drew a self-portrait, and the chances are they'll tell you it was a long time ago. It's one of the first things we draw at Primary (Junior) school, and yet so many of us leave it at that. Even professional artists and those who draw regularly seem reluctant to delve into this most empowering of art forms. Most of us don't think twice about taking a selfie (or ten!) — so why so anxious about drawing them? Fear? Modesty? Loathing? All good reasons to 'go there'! Self-portraiture can break through these barriers and lead to a more self-confident and fear-free approach to life.

BE YOUR OWN MUSE

Whatever the subject, drawing is a therapeutic experience and a brilliant way to practice self-care: draw yourself and the mental health benefits run even deeper. When we draw something, we develop a better understanding of the subject that we are drawing; so it makes perfect sense that self-portraiture can bring us closer to ourselves. The emotional space it brings us into can be pretty challenging, but break through the discomfort and you will reap the rewards, as you discover and develop new levels of self-confidence and self-love. Ultimately, self-portraiture is something we can return to time after time, as a form of meditation and self-care that we can enjoy regardless of what else is going on in our lives — become your own muse and you will have a companion for life.

GET REAL!

Frida Kahlo's trademark monobrow is an empowering emblem of a woman who had the courage to 'get real' and challenge Western society's aesthetic of 'perfection'. Nowadays we are all so quick to edit out the things that make us interesting and unique, but perhaps we could all benefit from being a bit more 'Frida' about things! Drawing self-portraits gives you an opportunity to explore and express yourself without a filter, to reflect on the *real* you and take control — not of how you look, but of how you *feel*.

'I AM MY
OWN MUSE.
I AM THE
SUBJECT I
KNOW BEST.
THE SUBJECT
I WANT TO
KNOW BETTER.'

FRIDA KAHLO

A (VERY) BRIEF HISTORY OF SELF-PORTRAITURE

Self-portraiture burst onto the scene back in the mid-15th century, during the European Renaissance, when mirrors became widely available and enabled artists to see themselves clearly for the first time. Can you ever imagine life without them?! Self-portraiture rapidly became a popular form of self-promotion for artists, helping to advertise their skills to prospective clients and to secure those all-important commissions. They were, for artists, a truly new game-changing marketing tool!

Self-portraits from this era were often highly finessed and laboured works of art – deftly drawn and perfectly rendered. Remember there were no cameras at that time, so likeness was essential and photorealism was bang on trend. To this day, so many people think the measure and purpose of a 'good portrait' is capturing a photographic likeness; it's no wonder so many people find drawing faces a challenge. These portraits from the Renaissance, while impressive and highly valuable, have a lot to answer for!

On the positive side, the Renaissance gave rise to Individualism. This was a movement which reaffirmed the importance of the individual in society and of being one's own person. Unsurprisingly, many iconic European artists are renowned for their self-portraits, including Leonardo da Vinci, Rembrandt, Sir Joshua Reynolds, Gustave Courbet and Edvard Munch, to name but a few.

The dawn of photography in the 1840s diminished the demand for artists to create realistic portraits of others, and so portraiture moved into new territory. Artists began to use it as a way to explore and communicate the 'inner self', rather than simply to recreate the 'outer self'. The Surrealists pioneered the movement towards a broader interpretation of the self-portrait, an expansion which continues to this day (think Andy Warhol, Cindy Sherman or Tracey Emin). Today, self-portraiture continues to be challenged, redefined and showcased on a global stage.

OMG!

Edward Munch's 'The Scream' is one of the world's most iconic self-portraits and a universal symbol of human terror. By abandoning likeness and dehumanising his looks, Munch's portrait succeeds in representing and speaking to the whole of humanity – we've all been there and felt that! It was sold at Sotheby's in 2012 for $119.9 million, making it the world's most expensive work of art ever to sell at auction, and proof that portraits don't have to capture likeness to be powerful!

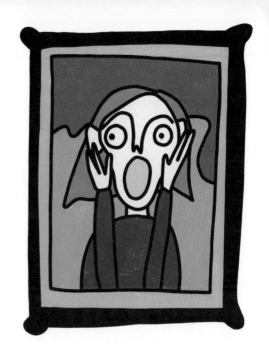

#REMBRANDTROCKS!

We might think of self-promotion and personal branding as a 21st century trend, but Rembrandt was rocking it way back in the Renaissance. Unlike many of his contemporaries who worked as 'court artists', Rembrandt was an independent artist and so had to work extra hard to get gigs. In his early career he created dozens of self-portraits which he used to advertise his skills to prospective clients. No doubt if he were alive today he'd be killing it on Instagram!

A NEW
WAY OF SEEING

Drawing can't change the way you look, but it can certainly help to change the way you see: both in the way that you see drawing, and in the way that you see yourself.

I'm going to make a sweeping generalisation and say that most of us spend more time looking at the world (and ourselves) in a critical light, than we do in a creative and compassionate way. From spelling errors to shifty-looking strangers, as humans, we're hard-wired to keep an eye out for danger and to clock anything that seems unfamiliar, out of place or 'wrong'. A lot of us spend our days with our eyes glued to our screens: staring at and yet ironically never connecting with what we're looking at, because it changes so fast we don't have time to dwell on it. We can spend hours searching the Internet, but will never find or see into its depths, because, TRUE FACT: THE INTERNET HAS NO SOUL!

When we look at things through the eyes of our 'inner artist', we retune our vision and experience the world on a much more profound and emotional level. We engage our curiosity and creativity, and we begin to contemplate and see beyond the superficial. When we look at a subject and begin to draw it, we start to concentrate on what we see. We observe and interpret details, colours, textures, characters, energy and emotions; soaking it all up as source material to infuse and inspire our creations. As we do so, our minds become more sponge-like; simultaneously absorbing the new and rinsing out the old, squeezing out our mental clutter in order to make way for these fresh droplets of inspiration.

When we draw, we meditate and we learn. We might not think so, but we ALL have the capacity to see things in a unique and imaginative way, and taking part in the art challenges in this book will help you to strengthen and express your creative vision. The more time you can spend looking at yourself – and at the world – through the curious, compassionate eyes of your 'inner artist', the better!

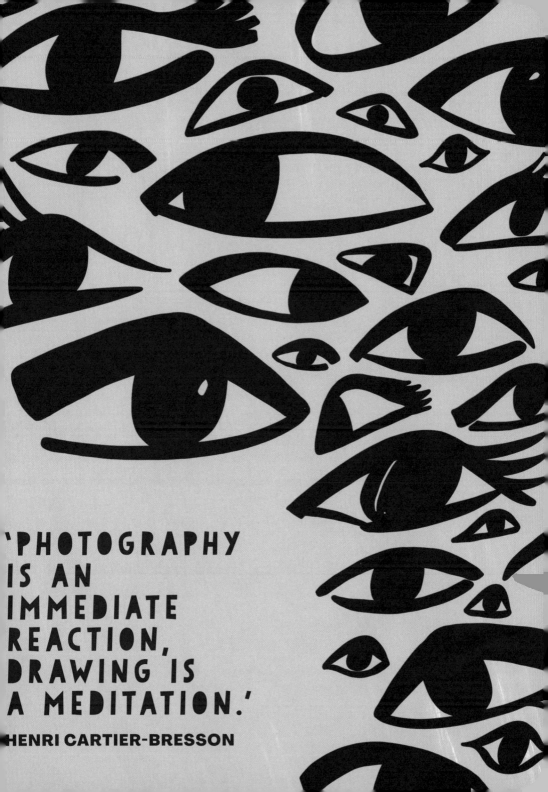

'PHOTOGRAPHY
IS AN
IMMEDIATE
REACTION,
DRAWING IS
A MEDITATION.'

HENRI CARTIER-BRESSON

HOW TO USE THIS BOOK

There's no 'right' way to use this book – the challenges can be done wherever and whenever you like. The prompts in The Challenges section (pages 34–189) are designed to be one-offs, whereas the Self-Care section at the end (pages 190–215) contains activities that are good to do on a regular basis. The main challenge prompts are grouped into themes and become progressively more experimental, so you might want to start at the beginning and work your way through the book as your confidence grows. That's not to say you can't mix it up; this is *your* time and *your* journey, so just YOU DO YOU!

The book contains a mixture of activities, some that can be done on the page and others that are designed to be done in your own sketchbook. I know lots of creative folk are quite particular about their paper size, weight and so on, so I am offering a variety to give you the chance to express yourself on whatever scale you feel like!

CARVE OUT TIME FOR ART

Whether you manage a daily drawing or binge-sketch at weekends, just do it your way and don't beat yourself up if you skip a day. This is a course of creative self-care that you can follow at your own pace, in your own way. However and whenever you complete it, you'll still feel the benefits!

FIND YOUR HAPPY PLACE

This book is all about indulging yourself, so find a cosy and private spot to sketch your self-portraits: somewhere free from distractions where you can get lost in the creative flow. Put on a comfy sweater, light some candles, play some music in the background; the more comfortable your sketching space the more likely you'll be inspired to hang out there!

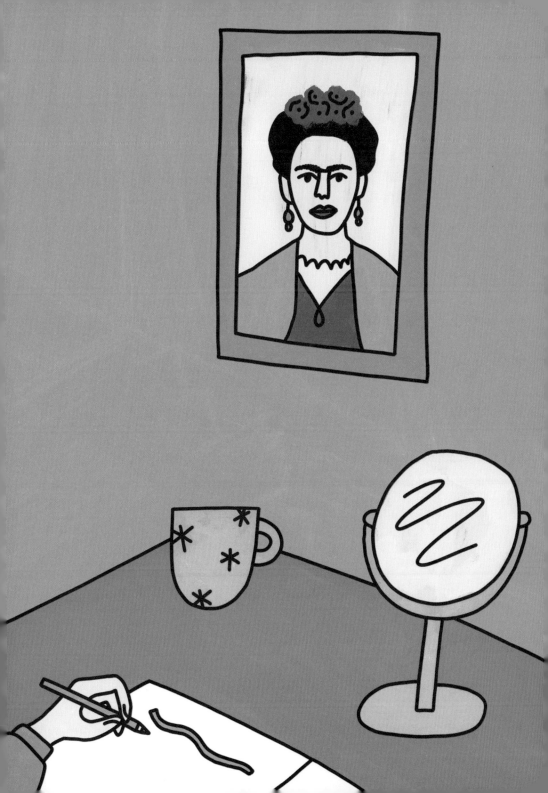

TOP TIPS!

Over the years, I've experimented with a lot of different materials and amassed a pretty large art stash. Art supplies can get expensive, but if you are able to, I'd recommend giving these a whirl – all great for portraiture. Maybe treat yourself to a new 'toy' every month?

- **POSCA (paint) pens = THE BOMB!**

- **Black drawing ink**

- **A basic set of watercolours (REEVES do a great set that is really reasonable)**

- **Oil pastels**

- **Cheap wax crayons – your inner child will love them!**

- **Posh wax crayons – I love Caran D'ache NEOCOLOR**

- **Brush pens – Tombows & Ecoline brush pens are LUSH!**

This list is not exhaustive (obviously), but it's just some of my favourites!

If you enjoy drawing with music on in the background, why not make yourself a playlist full of all of your favourite feelgood songs? If you find it hard to take time out to draw, creating a series of shorter playlists (e.g. 15 minutes long) could help you to stick with the challenges and ensure you get some daily 'sketchercise'! The more manageable and frequent you make it, the greater the results will be. If it works for Joe Wicks…

You could create several playlists to suit different moods and days of the week. Get thinking and write some ideas down below!

REMEMBER: CURB YOUR CRITIC!

Don't be afraid to go 'wrong', because you can't! Try to silence your inner critic and remember that this is a personal project, and that there's no such thing as a 'perfect portrait'. Just luxuriate in the creative process and the time you have carved out for you. We don't all smash out a marathon or hit our PB at the gym every day, but that doesn't take away the benefits of regular exercise. The same goes for drawing! We can get as much out of producing 'average' everyday sketches as we do out of creating something that we feel is really 'good'. In the flow is where we feel the most benefit, and most importantly, it's where we feel the most 'us'!

TIP: If you do draw something you're not so happy with, DO NOT DISCARD IT! Use it as an opportunity to experiment. Draw over it, turn it into something new, make it 'abstract', give it a silly title…Your efforts are too precious to throw away! Be bold and be confident in your lines — embrace every smudge and every squiggle!

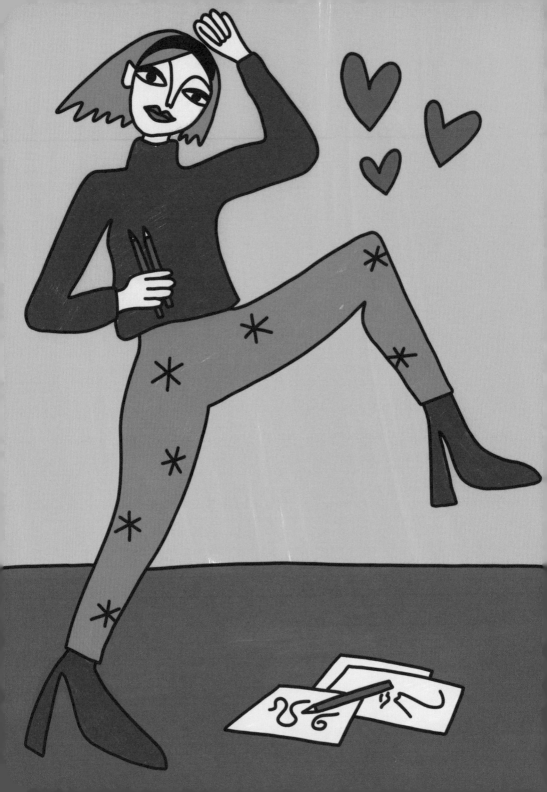

GET SOME SKETCHERCISE!

TAKE NOTE:

Drawing is seriously good for your mental health! It has been clinically proven that it:

· Boosts cognitive function and memory.

· Improves hand-eye coordination.

· Sharpens observation skills.

· Improves concentration and focus.

· Help us to connect, learn and understand the world around us.

· Deepens our intuition and empathy for others.

· Produces serotonin, endorphins, dopamine and norepinephrine – all the good brain stuff!

You'll find a little pencil icon beside all the challenges in this book. If you fancied sharing any of your work, I'd be so excited to see it! Follow and tag **@sketchappeal** on Instagram and Twitter.

You'll notice this star appears throughout the book too, beside the profiles of some of my favourite contemporary artists who have provided me with many flashes of inspiration!

THE CHALLENGES

'YOU USE A GLASS MIRROR TO SEE YOUR FACE; YOU USE WORKS OF ART TO SEE YOUR SOUL.'

GEORGE BERNARD SHAW

THE WARM UP

Sit yourself in front of a mirror and have your sketchbook and drawing tools at the ready. Spend at least 1 minute looking at your reflection before each of these warm-up exercises. Your eyes may flit straight to the things that look out of place, but just observe them and then move on (to more exciting things!).

Take some time to observe the colours in your eyes, your pupils and your eyelashes. Can you see any emotion? Look at the angles of your face and your bone structure. Check yourself out, take in every pore and feature as if for the very first time. Smile. Stick your tongue out. Remind yourself that this amazing face of yours has 43 incredible muscles that can make your skin dance and your mouth smile, your brows furrow and your eyes pop! Take time to touch your skin and feel the contours of your face.

After each sketch, make a note of how you feel, or whatever words come to mind. Don't pass judgement on your work. It's not meant to look like you, but hopefully it will help you to feel and reconnect with you!

1. Spend 10 minutes drawing a self-portrait, looking up and down at the page as many times as you need to for reference.

2. Repeat the above but draw for 5 minutes and DO NOT look down at the page as you draw. Remember to blink — you're not trying to stare yourself out!

3. Repeat for a third time, but this time don't lift your pen off the page at any point until the 5 minutes is up. DO NOT LOOK DOWN!

4. Look deep into your eyes for a minute and then close them. Spend 5 minutes drawing whatever you remember.

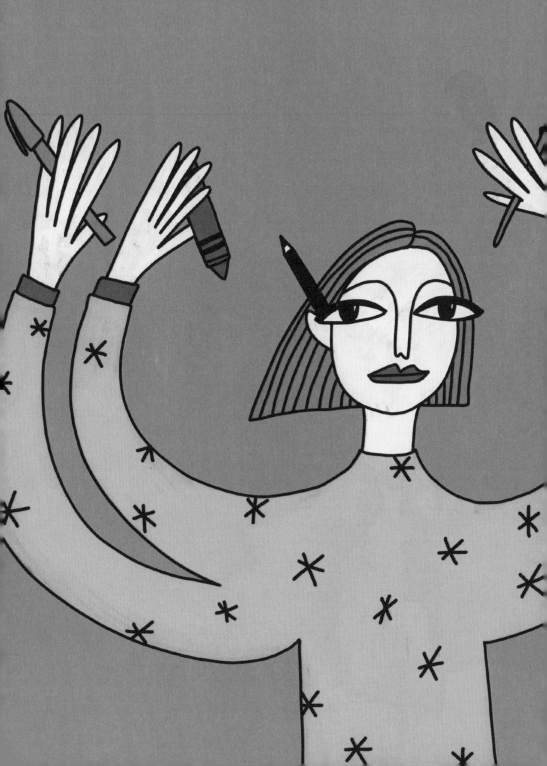

MIX IT UP

The challenges in this section are all about mixing it up and experimenting with different materials and ways of drawing. I use a lot of these as warm ups at my workshops to get people to open up to new ideas, and to stop overthinking or worrying about achieving a 'perfect' end result. Prepare to get out of your comfort zone and into the playful, creative spirit of childhood!

You might like to select one photo of yourself to draw from repeatedly, so you can see the difference in all the portraits you create and impress yourself with your own versatility!

Draw yourself using your dominant hand.

Draw yourself using your non-dominant hand. I bet you prefer
this one and it captures more of your true essence!

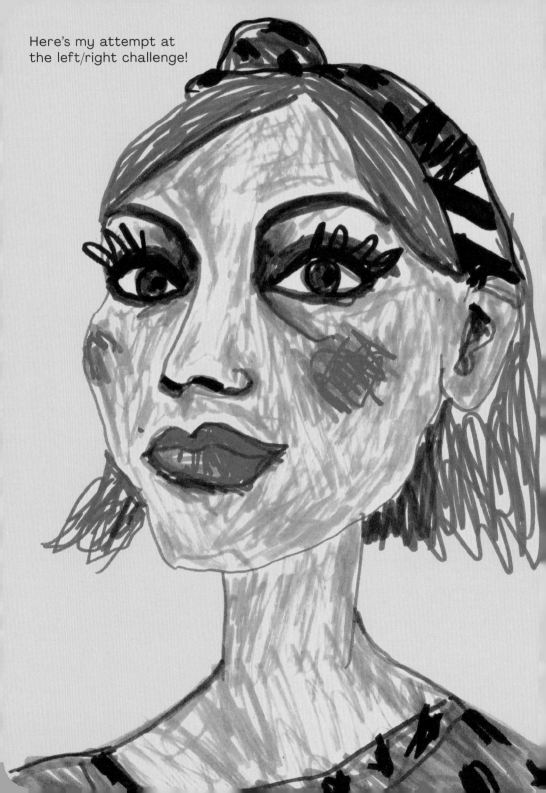

Here's my attempt at
the left/right challenge!

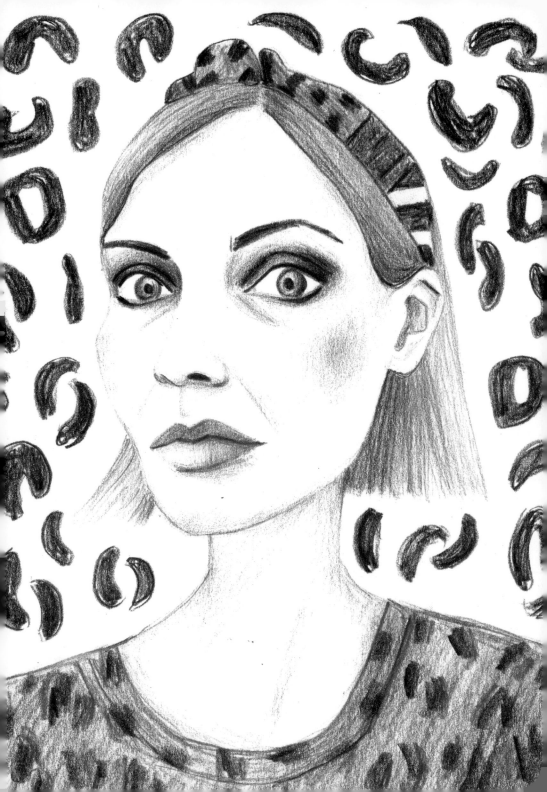

Draw a self-portrait using 2 pencils at the same time.

Draw a self-portrait without taking
your pen or pencil off the page
(using one continuous line).

Draw a self-portrait without looking at the page.

➤ Draw a self-portrait with your eyes fully closed.

Here are my attempts at drawing with my eyes closed, and with 2 pens at the same time.

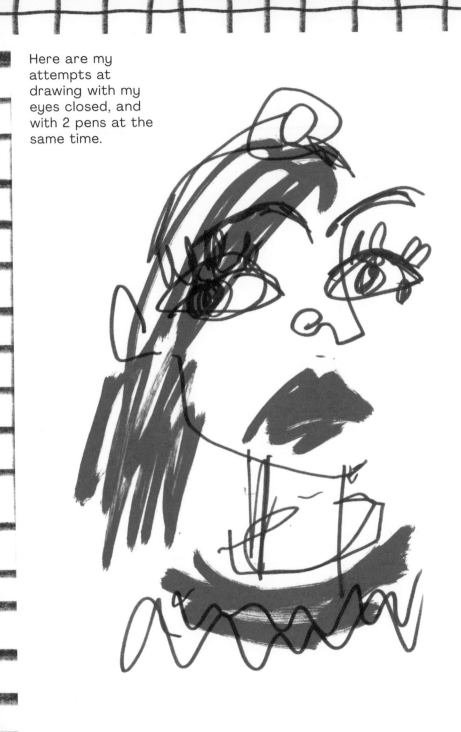

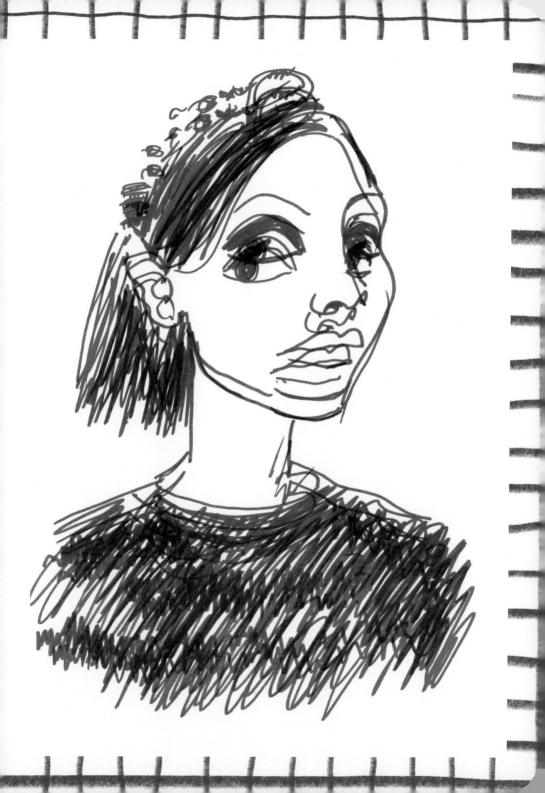

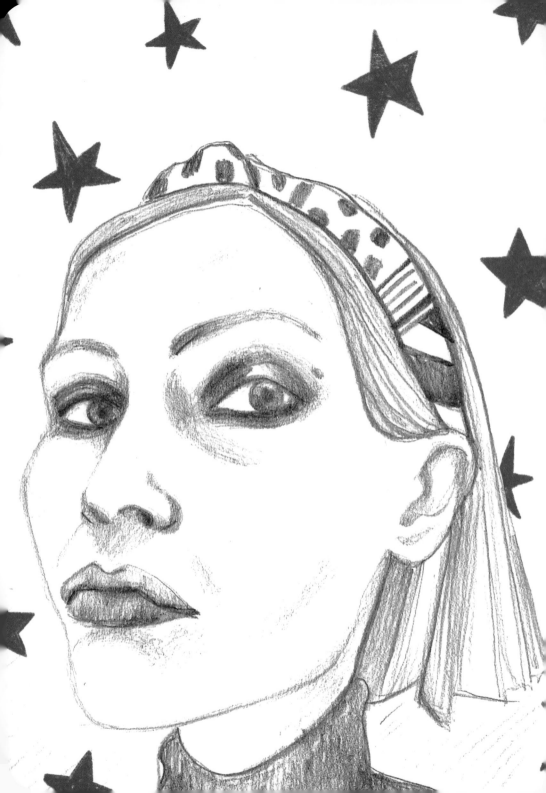

■■▷ Draw a self-portrait using only pencil.

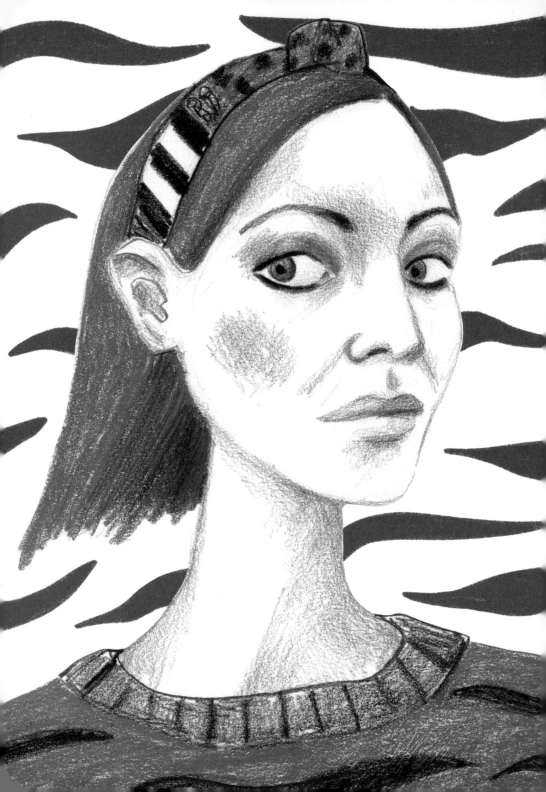

■▶ Draw a self-portrait using only coloured pencils.

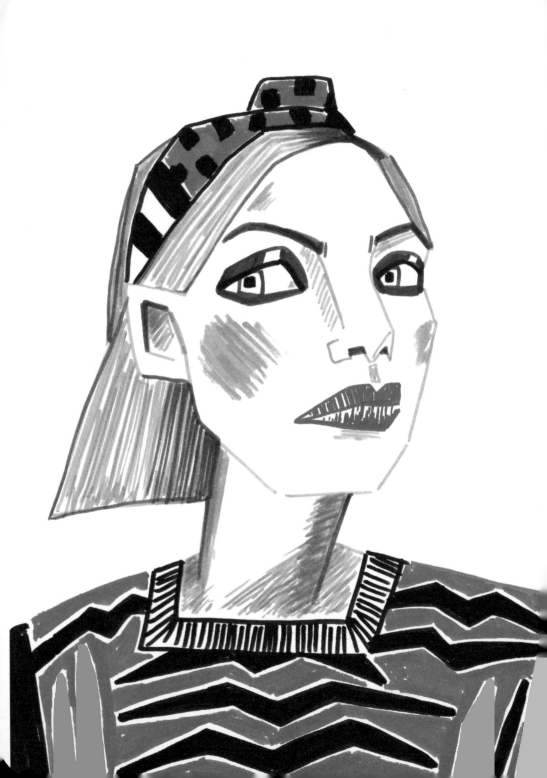

■▶ Draw a self-portrait using felt-tip (marker) pens.

HOLLIE FOSKETT

Hollie Foskett is an artist and student living and working in Portsmouth. I LOVE Hollie's sketching style and have been captivated by her work since I first laid eyes on it. From the bittersweet to the utterly blissful, her portraits carry such charm, character and truth. Hollie says she gets most of her inspiration from past relationships, love and toffee crisps, and that she loves planting flowers, deep conversations and eating pasta with an inhuman amount of mayonnaise! I asked her to take a break from all of that to answer a few questions…

What does self-love mean to you? It's such a journey for me. It's taken me so long to see that self-love means accepting things about you that you find hard to face. Forgiveness plays a huge part in it for me. Happiness is like the tide: one moment it's right under your feet tickling your toes, the next it is far away shallow and distant. But it always comes back.

How important is creativity to your mental health? Everything I have felt and everything I do feel is out there on the paper, tucked inside sketchbooks and hangs off my bedroom wall. I surround myself with my mental health to better understand it. It is absolutely my greatest outlet and insight.

Has drawing and making art helped you to overcome challenges? Absolutely. When I am drawing it's almost as though I am in a therapy session: I am working through the problems by laying it out on the page. And being confronted with my own image and what I am going through looking back at me, I am then able to break it into separate pieces and empathise, instead of trying to bury my own emotions.

Any favourite mood boosters? Going out on my bike is always nice. I also like to sit in the sun and listen to music and imagine my life is a sitcom or a movie. Or I bring all my houseplants outside and sit among them and drink water and pretend I am growing too.

Follow Hollie **@bitsifind** on Instagram.

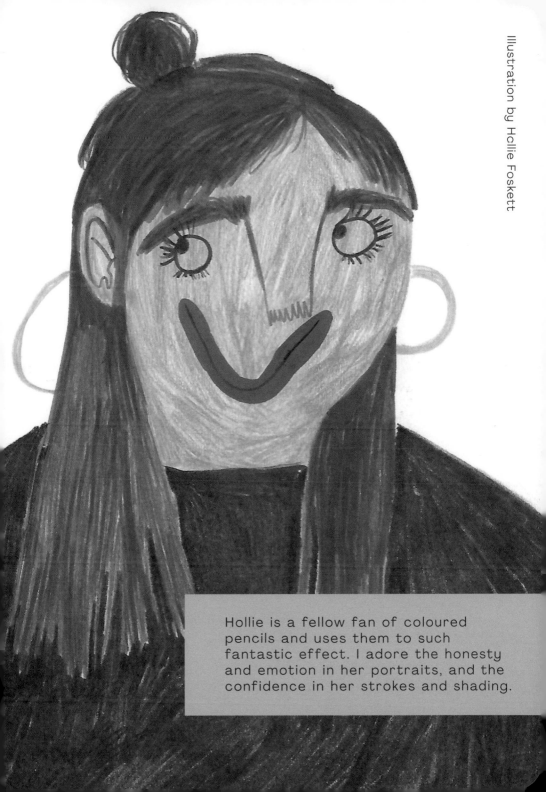

Illustration by Hollie Foskett

Hollie is a fellow fan of coloured pencils and uses them to such fantastic effect. I adore the honesty and emotion in her portraits, and the confidence in her strokes and shading.

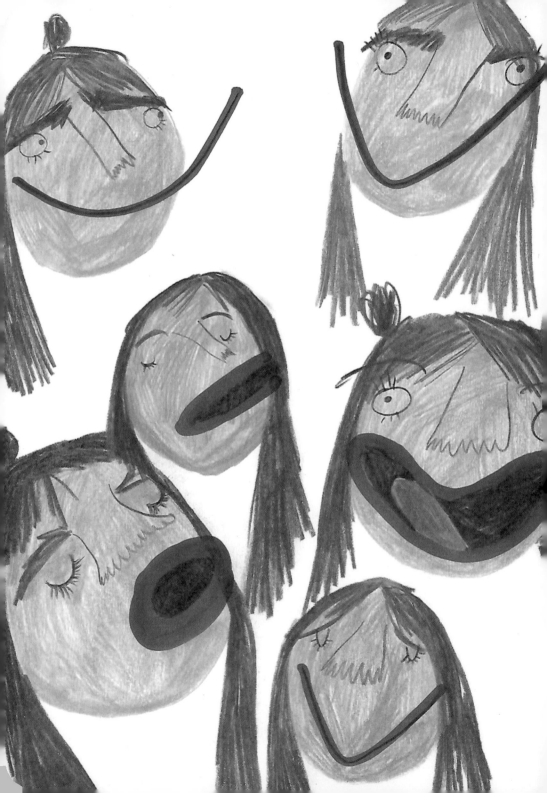

Look at the way Hollie shades and draws facial features.
Draw a self-portrait inspired by her style, using coloured
pencils, obv!

SKETCH THE RAINBOW

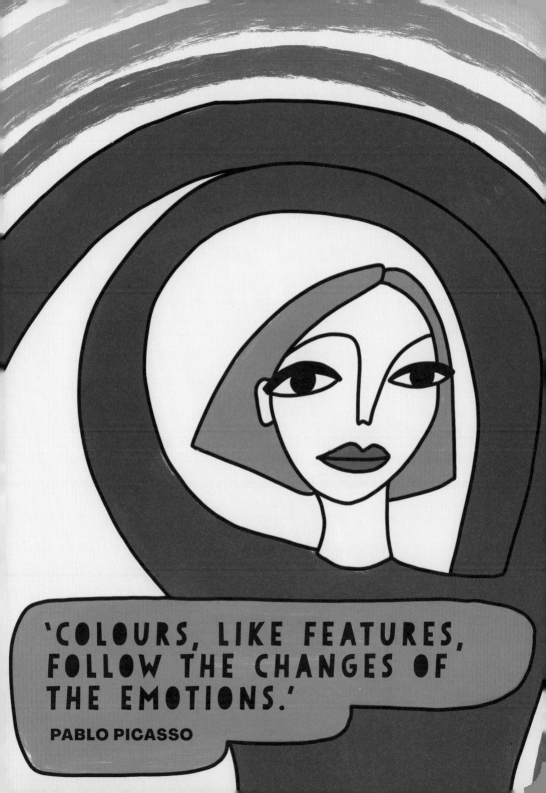

'COLOURS, LIKE FEATURES, FOLLOW THE CHANGES OF THE EMOTIONS.'

PABLO PICASSO

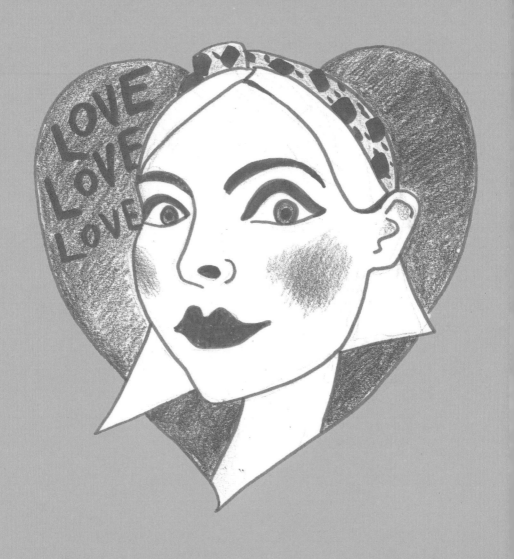

I LOVE orange! It makes me think of Autumn (fall), Seville and my mum – all things I love! Use the page opposite to draw a self-portrait using one of your favourite colours, and while you're at it think, 'why do I love it so much?'.

If you're familiar with screenprinting or risographs then you'll be familiar with these colour palettes. Pick one and use it to draw a self-portrait on the page opposite. No black lines allowed!

Here are some classic tricolour combinations. Pick one you've not used before and draw a self-portrait on the page opposite.

When you're done you could try out the rest in your sketchbook, then come up with a colour combination of your own!

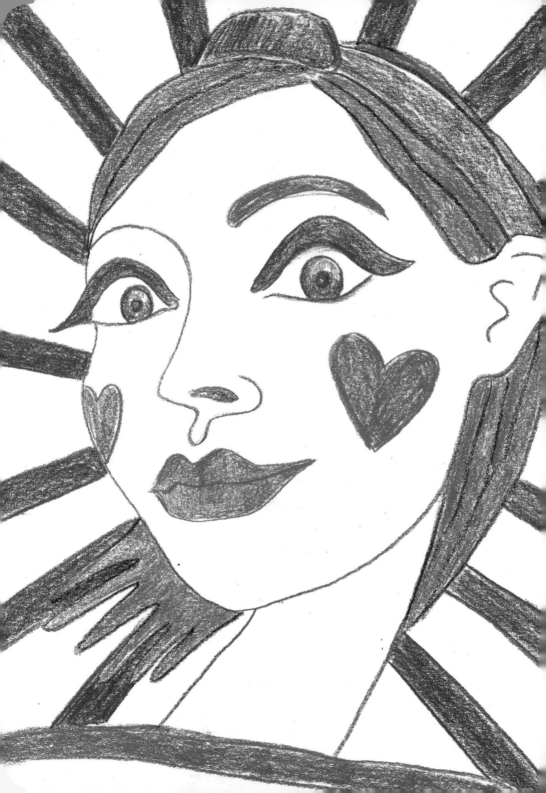

MORE IDEAS

This is one of my favourite colour combinations, as you'll see a little later in the book. Once you've settled on your favourite, why not have a play with different drawing materials or drawing styles. I used coloured pencils, wax crayons, felt-tip (marker) pens and a mixture of all 3 to create these portraits.

CLAIRE PROUVOST

Claire Prouvost is a French illustrator, painter, designer and street artist based in Dublin, Ireland. Known for her drawings of charismatic women in a bold, pop and minimalist style, Claire draws inspiration from fashion photos from the 1970s imbued with lightness and primary colours. I find her illustrations utterly captivating – such style and sass! Having followed her journey for a while, I know that self-love is a matter close to Claire's heart, so I was only too delighted to ask her a few questions!

What does self-love mean to you? Appreciating yourself and what your true emotions and interests are; accepting and embracing the reality of your body and your mind in the present moment, without judging or trying to change any of it.

What impact does creativity have on your mental health? HUGE! I got back to drawing during a hard time in my life, and by doing the 100 days projects, it really allowed me to heal and I discovered so much about myself in that period. I came out of that difficult time feeling so much more confident that I found my true passion and also became more at ease with myself. It was healing, and an amazing way into self-discovery. When the pressure is on, I feel the urge to draw for myself in order to take that time as a 'self-care moment'.

Do you have a favourite creative mood booster? I get sooo excited collecting new images. I would scroll through the fashion photo section of my Instagram or Pinterest and will find tons of inspiring images to refer to.

How do you relax and practice self-care? I always meditate first thing in the morning and throughout the day if I am feeling overwhelmed. In the evening, I light a few candles, spray some aromatherapy spray around the room, and make sure the setting is warm and inviting. I normally pick up my messy sketchbook to draw in – without any pressure – or paint for an hour. Then I turn off the light early, to get a good night's rest.

My top life tip? Keep smiling and creating!

Follow Claire **@claire.prouvost** on Instagram.

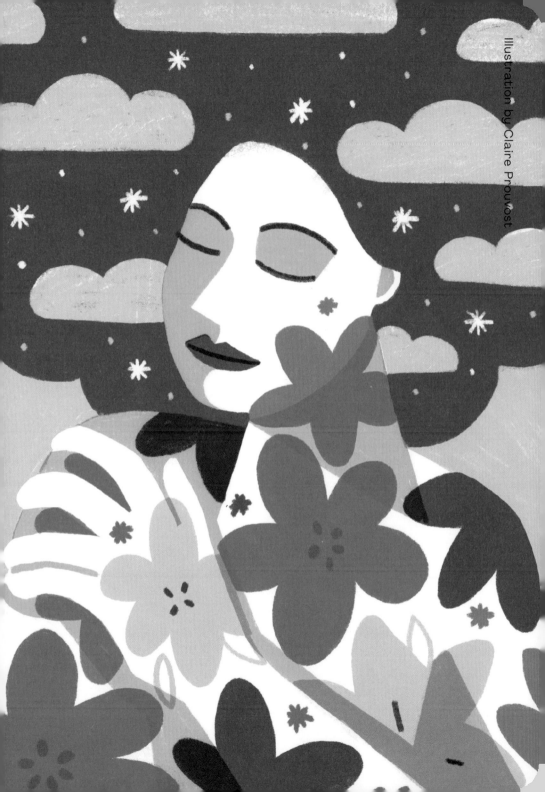

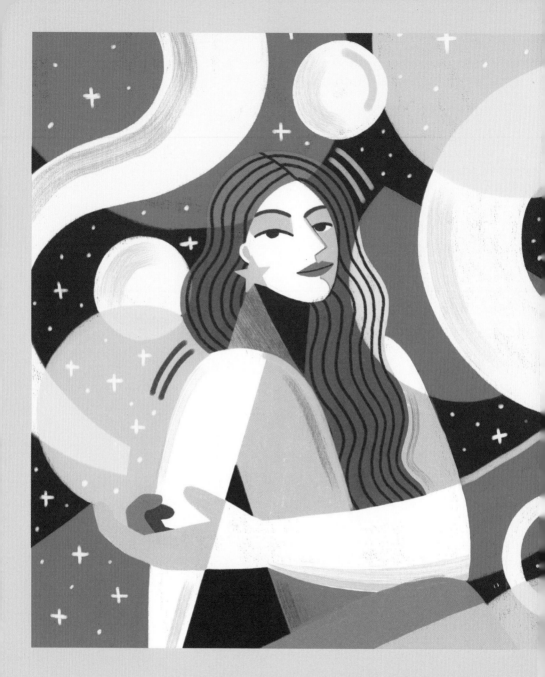

Claire is one of the pioneering artists behind #**MagicMoonWeek** – a fab Instagram drawing challenge that is well worth looking up.

Take inspiration from Claire's illustration and use this page to draw yourself as a Magic Moon Goddess, using some or all of Claire's colour palette.

Illustration by Claire Prouvost

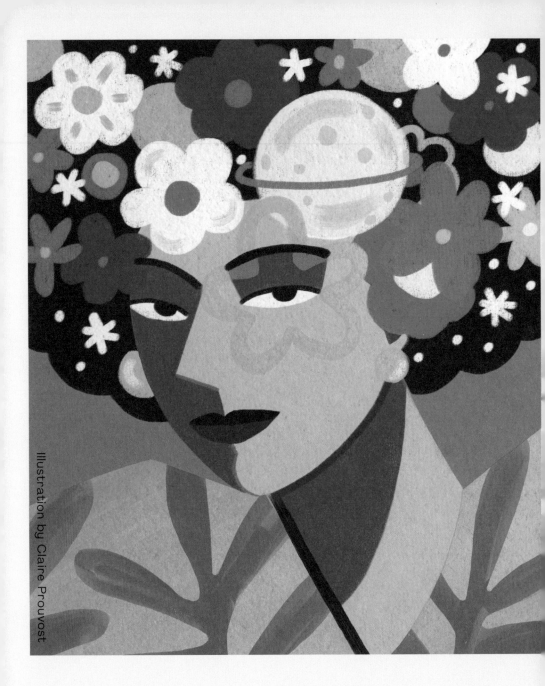

Illustration by Claire Prouvost

Take inspiration from this gorgeous illustration by Claire and draw a flower-powered self-portrait in your own sketchbook.

CLAIRE'S TOP TIP: 'LESS IS MORE!'

Claire credits her bold and confident use of colour to some advice she was given three years ago: 'Someone told me to limit myself to a very limited colour palette to start with, and "exhaust" all the combinations out of these colours before moving on to others. I picked primary colours (ultramarine blue, vermillon, a warm yellow and a bit of white) and started playing with these 3 colours. Three years after that advice was given to me, I still feel very at ease with these three babies. I do use other colours now of course, but they are kinda reassuring and I don't have to think about what palette I am going to use all the time. It makes things simpler, and have become a part of my identity, so it is a win win!'

■▶ Using a block coloured background or coloured paper is a
great way to bring a simple line drawing to life. Give it a go
and draw a selfie here!

Draw a series of block coloured shapes on this page, then use a black liner to draw a self-portrait over the top.

■▶ Draw a self-portrait using only coloured dots.

SUE KREITZMAN

Artist, muse, fashion icon, NYC-born Sue Kreitzman certainly wears her (he)art on her sleeves. Sue had a long career as a food writer and broadcaster, until a creative epiphany led her into the world of art. She now spends her life immersed in paint, sculpting material and found objects. She may be nearing her 80th birthday, but as Sue herself says, she simply has no time to get old! 'Colour, art and fabulous outfits keep me emotionally stable and forever young.'

For me though, Sue's heart and passion for creativity shines brighter and bolder than any of her kaleidoscopic clothes. She has been a huge inspiration and support to me since we met, and is a big believer in the healing power of art. She's my guru, my friend and my superhero, and I'm so thrilled to have her in this book!

What does self-love mean to you? Being the best person I can be; not falling into the narcissism trap; engaging with others on their own wavelength. Being self-centered is never good.

How important is creativity to your mental health? Creativity is my life. Art is life and life is art. Without it, I would fly into a million little distressed pieces.

How has drawing and making art helped you overcome challenges? When I went through the menopause, it was pretty dreadful at first. Then I had a weird epiphany. Or a psychotic break. Or something. After 50 plus years of life and being surrounded by glorious colour, but knowing I could never ever make art myself, I began to draw. Compulsively. All night and all day. Mermaids, goddesses, characters right out of the female landscape. It changed my life. I became another person entirely. Miraculous, joyful, life affirming. I never take it for granted

What is your favourite creative mood booster? Colour, colour and more colour. In your face and in my face too! Around my neck, all over my walls, in my dreams. I can't live without it.

How do you relax and practice self-care? Drawing, painting, building sculptures out of detritus, fashioning profound (sometimes bonkers) neckshrines. And sometimes…I take a nap.

Follow Sue **@suekreitzman** on Instagram.

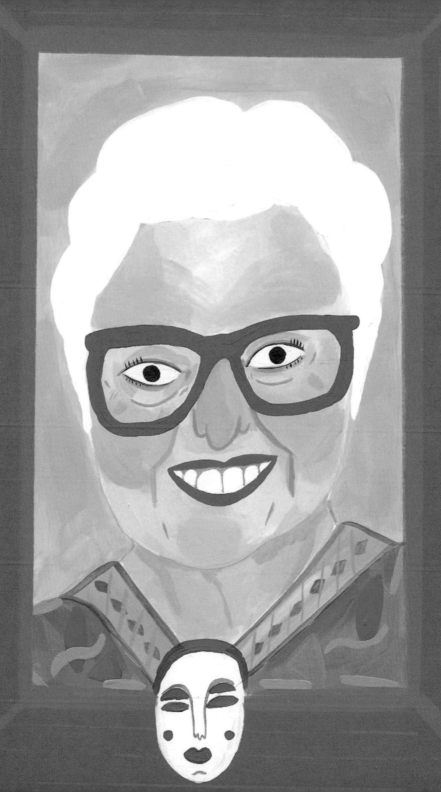

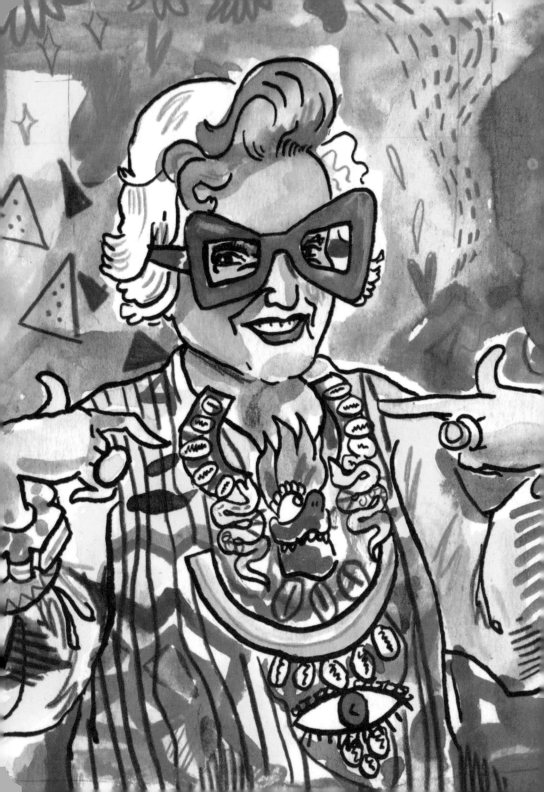

Draw a super colourful self-portrait that Sue would be dazzled by, using EVERY COLOUR OF THE RAINBOW!

STYLE STEAL

I meet so many people who say
they don't have 'a style'. In fact,
I often say that about my own work.
It's only natural to want to find our
own unique style, but we can learn
a lot from studying and 'stealing'
the style of others. Let's be clear,
this is not about ripping others
off; it's about experimenting with
someone else's technique and
letting it inspire and infuse
into your own. Even if you're
quite confident in your own
drawing style, it's always
good to try new things —
it could spark a whole surge
of new ideas!

The challenges in this section
are in honour of some of
the artists and artistic
movements that have inspired
me over the years. I hope you
have fun with them!

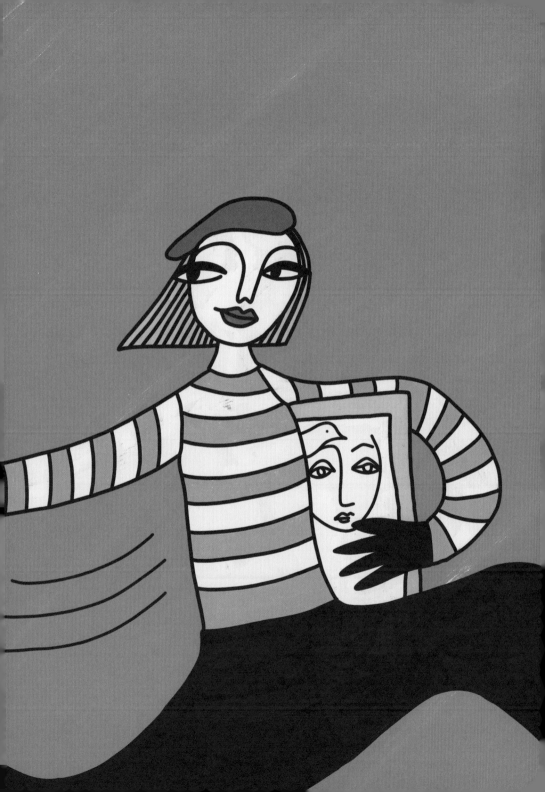

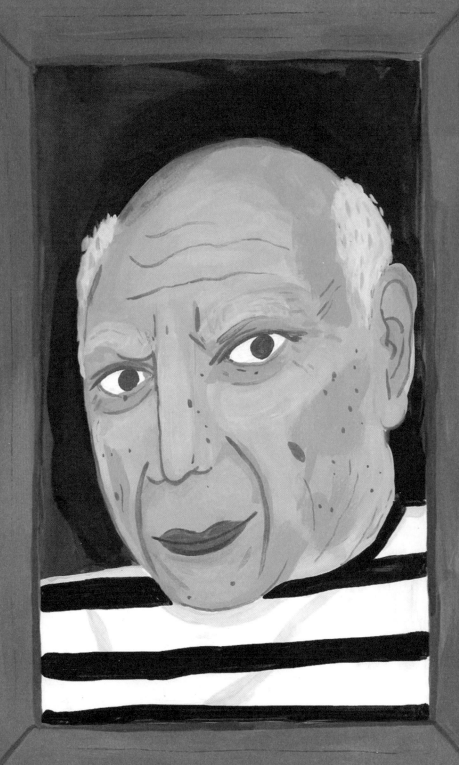

ALL HAIL PICASSO!

Picasso was one of the most prolific and influential artists of the last century, and if I have a 'favourite' then it's him! Picasso is noted for many things, including inventing collage and co-founding Cubism – he also rocked the striped top! Cubist artwork is so familiar to us now, but at the time – after centuries of photorealism – to deconstruct and depict the world in such a way was nothing short of REVOLUTIONARY.

It is estimated Picasso produced around 50,000 artworks in his lifetime – not all self-portraits I might add! He painted self-portraits from the age of 15 until his death, aged 90. His self-portraits document the way his style changed over the years and his remarkable evolution as an artist.

'EVERY CHILD IS AN ARTIST. THE PROBLEM IS HOW TO REMAIN AN ARTIST ONCE THEY GROW UP.'

PABLO PICASSO

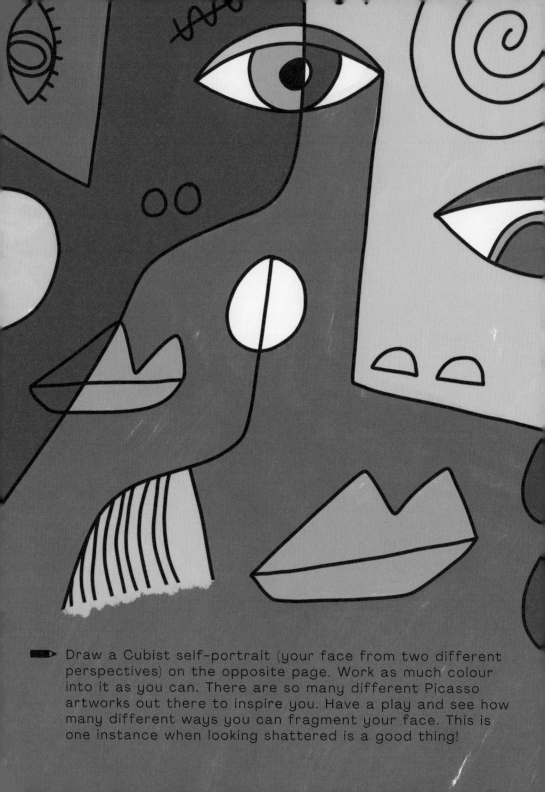

Draw a Cubist self-portrait (your face from two different perspectives) on the opposite page. Work as much colour into it as you can. There are so many different Picasso artworks out there to inspire you. Have a play and see how many different ways you can fragment your face. This is one instance when looking shattered is a good thing!

Picasso's line-drawings are as iconic as his paintings. Draw a self-portrait using just lines. Draw quickly and confidently, to give your portrait energy. TRUST YOUR EYES AND YOUR LINES.

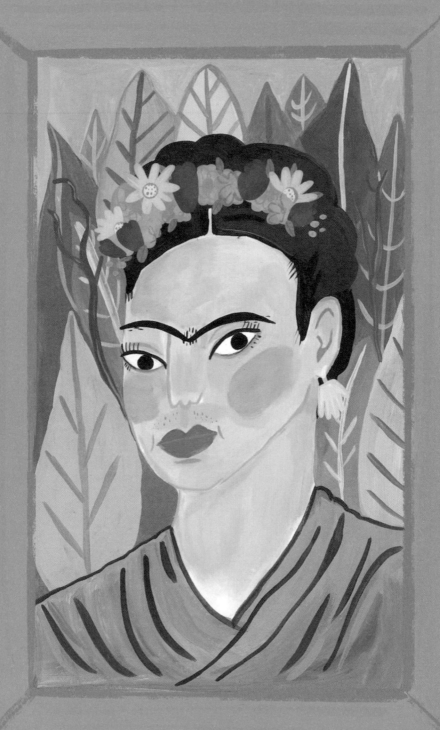

FRIDA POWER!

Frida Kahlo painted over 55 self-portraits, all loaded with symbolism reflecting her mental state and struggles. Frida channelled and explored her angst into art; embracing the superficial features that others might have seen as flaws (e.g. her monobrow) and conveying universal psychological truths that speak to us all. Think back even 20 years and consider how little we talked openly and publicly about ourselves and our mental health, and Frida's self-portraits become even more powerful. Frida's openness and willingness to expose the inner workings of her mind with such courage explains why she is such a widely revered (and replicated!) 21st century icon.

'I PAINT SELF-PORTRAITS BECAUSE I AM SO OFTEN ALONE, AND BECAUSE I AM THE SUBJECT I KNOW BEST.'

FRIDA KAHLO

Frida used plants, animals, bones and organs as symbols in her paintings to convey her internal conflict and emotions. What symbols would you choose to represent you and the way you feel? Think of a situation that you find either challenging or exciting, and then try to think of some symbols to represent that. Dig deep! In your heart, are you torn between two places (e.g. where you were born and where you live?). How could you convey that through symbols? (other than your national flag!). Who sits on your shoulder, loyal as a parrot, and what animal might they be?!

◼▶ Draw a Frida-inspired self-portrait incorporating some of your symbols. Monobrow optional!

Illustration by Nicola Fernandes

SALVADOR DARLING!

Naïve to his politics and ethics, Dali's work BLEW MY ACTUAL MIND when I first encountered it on a school art trip back in 1993. I was so captivated by his bizarre and brilliant landscapes of the subconscious (landscapes that couldn't have been further from my East Yorkshire homeland).

A notorious egomaniac, this Surrealist superstar was well-versed in 'the art of self-love'. Despite not appearing in the majority of his paintings, Dali's face is one of the most instantly recognisable faces in the world. He didn't create many conventional self-portraits, although he often appears metaphorically, and his mind is omnipresent in all of his work. From melting clocks to burning giraffes, Dali used symbolism and metaphor to explore the inner workings of his heart and mind. Turn the page and give it a go for yourself!

'HAVE NO FEAR OF PERFECTION – YOU WILL NEVER REACH IT.'

SALVADOR DALI

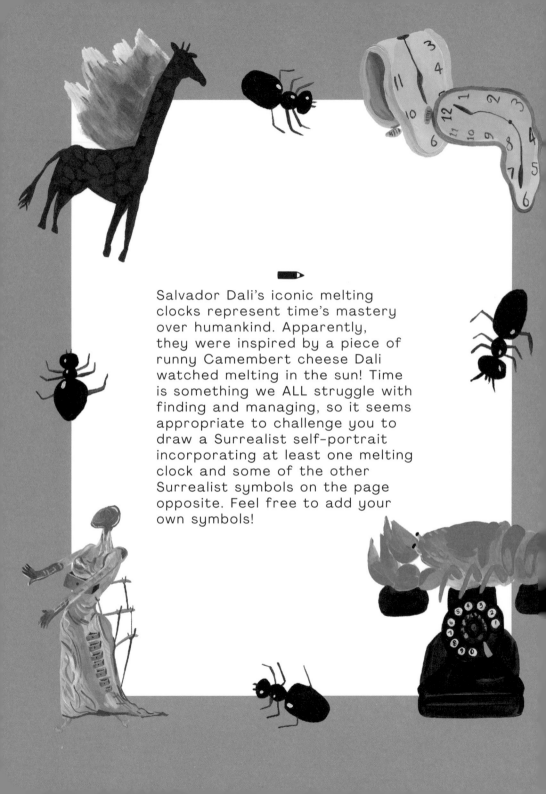

Salvador Dali's iconic melting clocks represent time's mastery over humankind. Apparently, they were inspired by a piece of runny Camembert cheese Dali watched melting in the sun! Time is something we ALL struggle with finding and managing, so it seems appropriate to challenge you to draw a Surrealist self-portrait incorporating at least one melting clock and some of the other Surrealist symbols on the page opposite. Feel free to add your own symbols!

HOCKNEY ROCKS!

David Hockney is a pioneer of Pop art and one of the most influential British Artists of the 20th century. Like me, he was also born in Yorkshire, so I felt it right that I feature him in this book. Like so many artists, Hockney has used self-portraiture as a tool for self-reflection and expression throughout his career; including a period in the 1980s when he drew a self-portrait every single day for 3 months. These sketches formed a key part of a major exhibition of his work at the Royal Academy in Spring 2020. So many artists remain enigmatic and overshadowed by their work, so this felt like a really secret and intimate insight into David Hockney as a man, without artifice – or even his trademark colour! The very fact these selfies were included wasn't just an indicator of the art world's renewed interest in self-portraiture, it was – to me – a brilliant reminder of the value of creating them!

'DRAWING MAKES YOU SEE THINGS CLEARER, AND CLEARER, AND CLEARER STILL UNTIL YOUR EYES ACHE.'

DAVID HOCKNEY

Draw a colourful self-portrait inspired by Pop Art. This is just my example, inspired my Lichenstein; you might like to look at other references, possibly involve some Warhol-style soup cans or bananas, too?!

Draw an abstract self-portrait on this page. Use shapes, colours, forms and bold marks in your drawing. Abstract portaits are such a great way to develop your imagination and break through the fear of getting it 'wrong'!

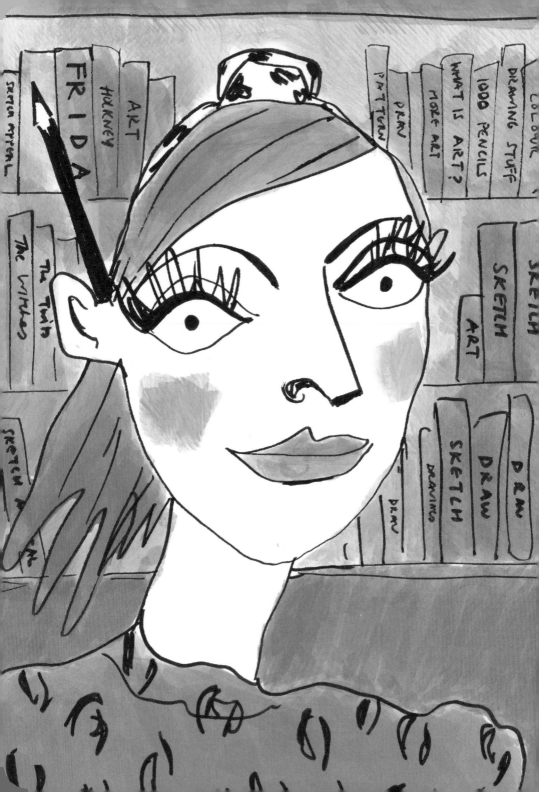

MORE FUN STYLES TO TRY...

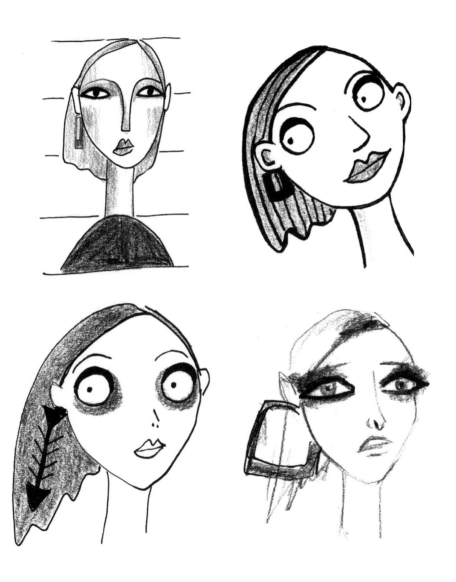

Left page, inspired by: Sir Quentin Blake; Above, clockwise from top left, inspired by: Modigliani, Axel Scheffler, Blairz and Tim Burton

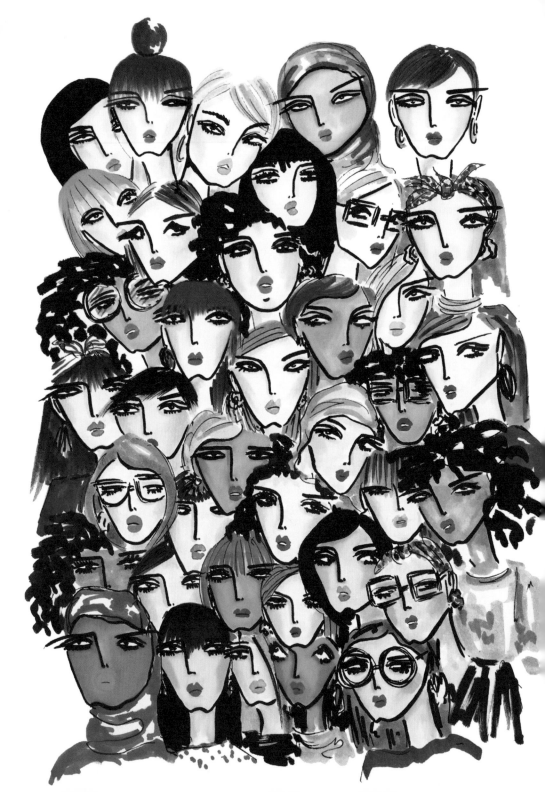

Fashion Illustrator Lianne Middeldorp drew the picture opposite – I adore her style! Why not try drawing a self-portrait inspired by her work?

Illustration by Lianne Middeldorp

'START COPYING WHAT YOU LOVE. COPY, COPY, COPY. AT THE END OF COPYING YOU WILL FIND YOURSELF.'

YOHJI YAMAMOTO

▬▶ Make a list of the illustrators and artists whose work and style you love, and then think about why you like it so much. Is it their use of colour? The way they draw noses? The character and humour? Study, emulate and experiment – it'll really help you to develop your creative confidence and sense of your own style.

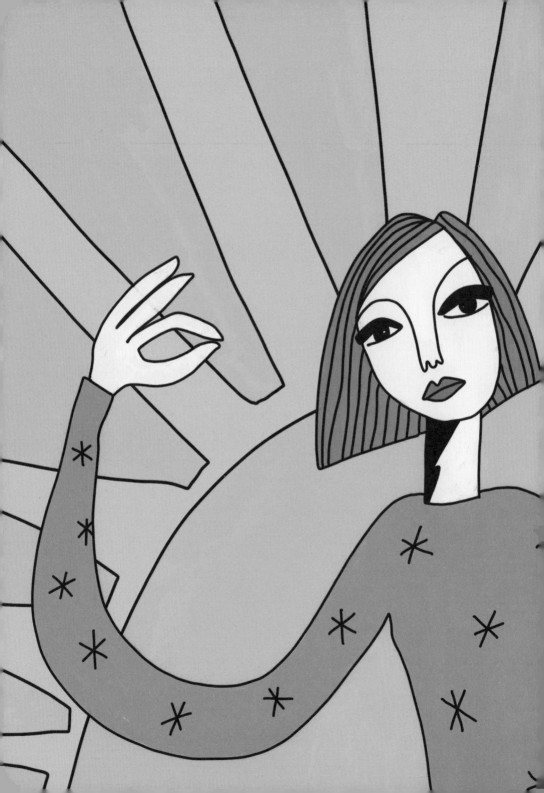

COMPOSE YOURSELF

Now that you've got comfortable drawing your face, the prompts in this section will show you a few different ideas and ways to compose and frame your self-portraits. These prompts are all about breaking away from the standard front-on headshots and exploring yourself from different angles: from extreme close-ups to crowded scenes.

▰▶ Draw a self-portrait showing just the top of your head peering down at the bottom of the page. Leave the space above it blank, or fill it with your dreams or thoughts.

■➤ Draw only half of your face.

Draw an extreme close-up of your face. You can choose which features to zoom in on!

■▶ Draw your face in profile view (side-on). You'll need to take a reference photo.

We've drawn a lot of selfies so far — now it's time to draw yourself taking one! This is such a simple way to create a really fun and interesting image, and a great way to practice drawing hands!

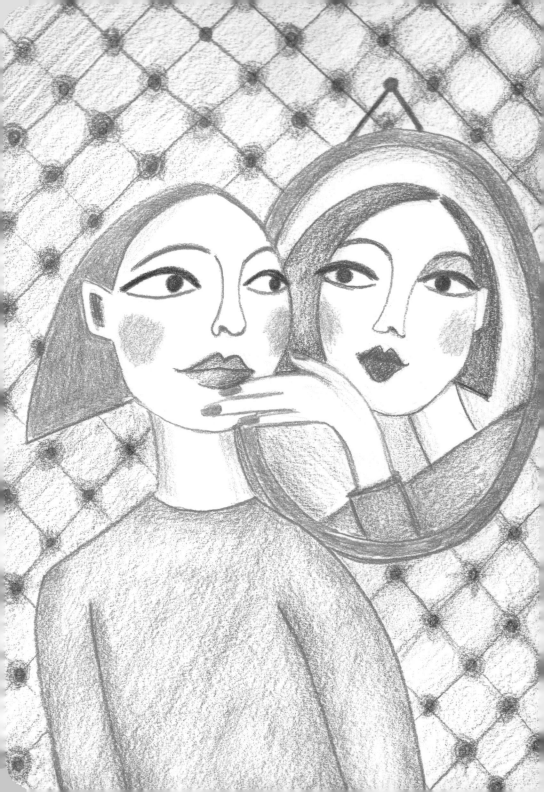

Imagine your reflection was a compassionate and loving friend with a life of its own. What would it say and do when you look into the mirror? Draw it here and be kind!

Do you suffer from imposter syndrome or feel like you're wearing a mask in certain situations? Draw yourself hiding behind one of them on the page opposite. This is me (clueless) and the focused face/mask I wear in my professional life. I drew the 'real' me with my non-dominant hand, because it always captures my 'true essence'!

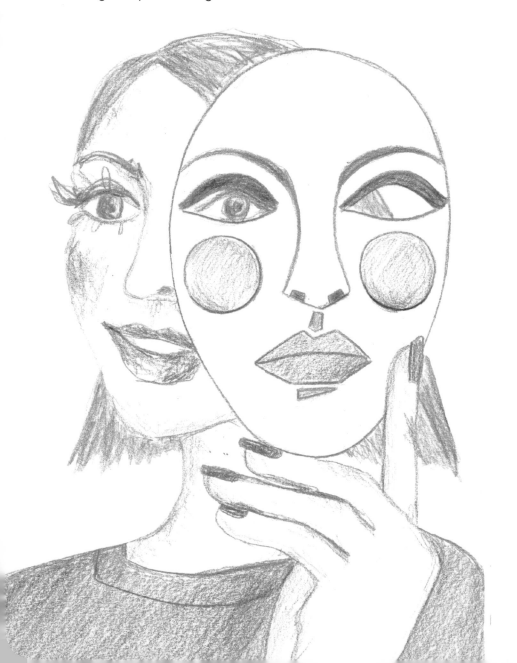

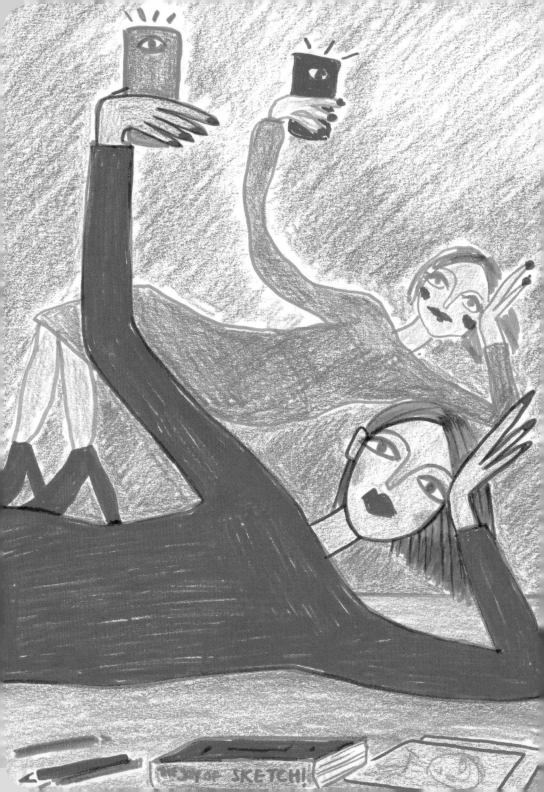

Now here's a fun one! Take a selfie in the mirror and draw your reflection with your dominant hand. THEN, draw another smaller version of yourself with your non-dominant hand, in whatever position feels most fun.

MAKE A
SKETCHYIBITION
OF YOURSELF!

▬▶ Fill this gallery with miniature self-portraits, using different styles, colours, materials and angles. Show-off what you've learned so far and make a real exhibition of yourself!

MARIA
INES GUL

Maria is a renowned London-based artist and designer with a background in textile design and a passion for using drawing as a tool for self-expression. From stylish fashoin portaits to witty lifestyle illustrations and iconography, her work is a magical mix of light and dark, sophistication and simplicity. I asked her a few questions.

What does self-love mean to you? Being your own best friend and trusting your gut.

How important is creativity to your mental health? Art is such a powerful and therapeutic tool. Drawing has always helped me to process difficult emotions and help them come up to the surface. Often I find it easier to express my feelings through drawing than trying to find the right words.

Has drawing helped you to overcome any challenges? It gave me a voice when I thought I couldn't have one. It continues to add a layer of magic to the mundane

What's your favourite creative mood booster? I like changing the tools, switching to collage, using a new colour, doodling while talking on the phone.

Describe your dream 'sketchdate'! Where would you go, with who? A walk in nature with Georgia O'Keefe, Eric Ravilious and Jockum Nordström. Something involving beautiful garments. An absolute dream come true was sketching Gucci at Westminster Abbey and at the preview of Mary Quant exhibition at the V&A.

Follow Maria **@mariainesgul** on Instagram.

Illustration by Maria Ines Gu

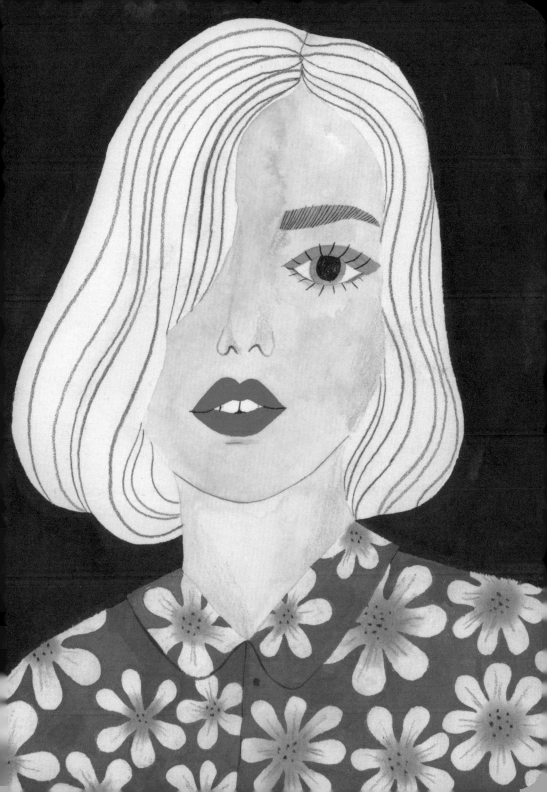

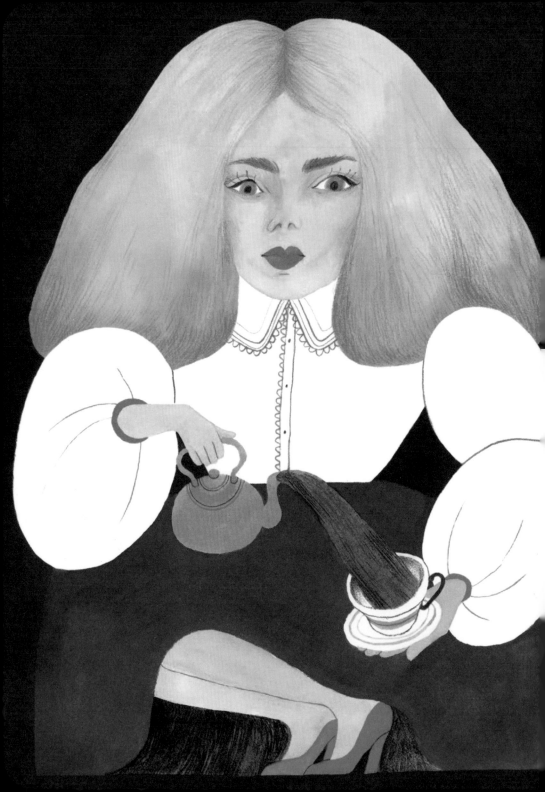

Ever wondered what you'd look like with massive hair and tiny feet? Now's your chance! Draw a (full body) self-portrait inspired by this illustration by Maria. Blow the rules of proportion and TAKE UP SPACE!

SASSY

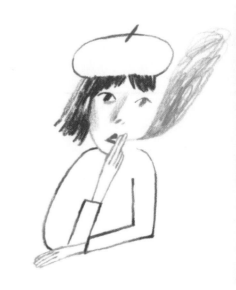

STRESSED

REFLECTIVE

LOVED UP

Maria is a master of communicating moods and emotions in the most minimalist and minature of ways. Take inspiration from her illustrations and draw some 'memojis' to represent some of your most common moods.

JAYDE PERKIN

Jayde Perkin is a freelance illustrator and award-winning comics artist based in Bristol. She creates hand-painted illustrations for a wide range of clients, as well as writing and making comics. I first discovered her work at East London Comic Arts Festival (ELCAF) a few years back, and I've been a huge fangirl of hers ever since! Jayde's work communicates the light and dark of life in a subtle but powerful way, through soulful illustrations that are highly relatable and utterly beautiful. She has delivered several talks about using comics as 'graphic medicine, and is a big believer in the therapeutic power of art. I asked her a few questions…

What does self-love mean to you? Not putting too much pressure on yourself. It's so easy to burn the candle at both ends, but all this pressure just leads to burnout. It's really important to chill, breathe, take stock.

How important is creativity to your mental health? For me, creativity has helped me a lot, I have been self publishing zines and comics for years, but my journey really began in 2016 when my mum passed away, and I began using these narratives as a 'place to put my grief', creating and making through really helped me make sense of a world, which felt as though it had been turned upside down.

How often do you draw? Most days! Sometimes more for 'work' than for 'fun' these days, but it's still fun, even when for work. I rent a studio space with some other creative people, so usually I draw there. But sometimes I like to draw in a coffee shop, or if the weather is nice I like to sit in the park and draw.

What's your favourite creative mood booster? For me it's about setting; it has to be away from the screens! As much as technology is a great resource and too in many ways, it doesn't allow me the space in my brain to think creatively. I like to get out of the house, or out of the studio. I go for a walk, sit with a coffee, in a café (if it's raining!) or in the park (if its sunny!), and draw.

How do you relax and practice self-care? I like doing yoga. Drawing all the time can take its tole physically, so I find taking that time out to move and stretch is really important. I also like to relax with friends and a couple of beers in the evening, but that's not quite as healthy.

Follow Jayde **@jaydeperkin** on Instagram.

Illustration by Jayde Perki

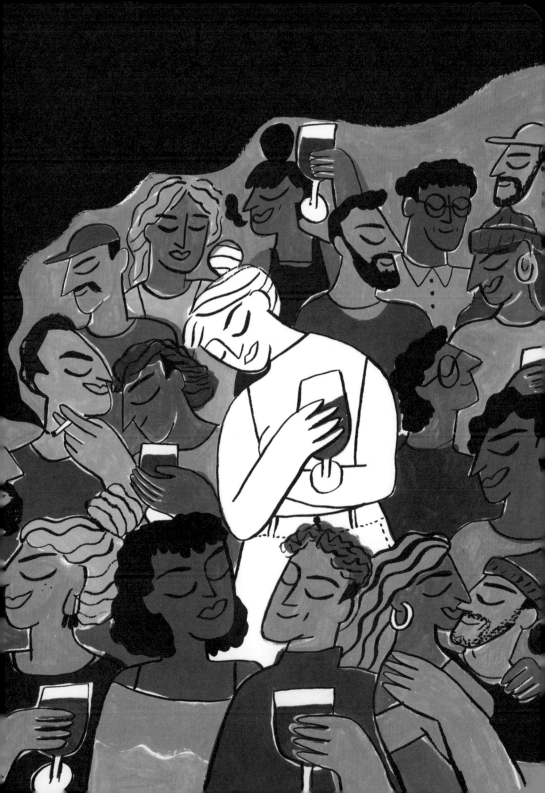

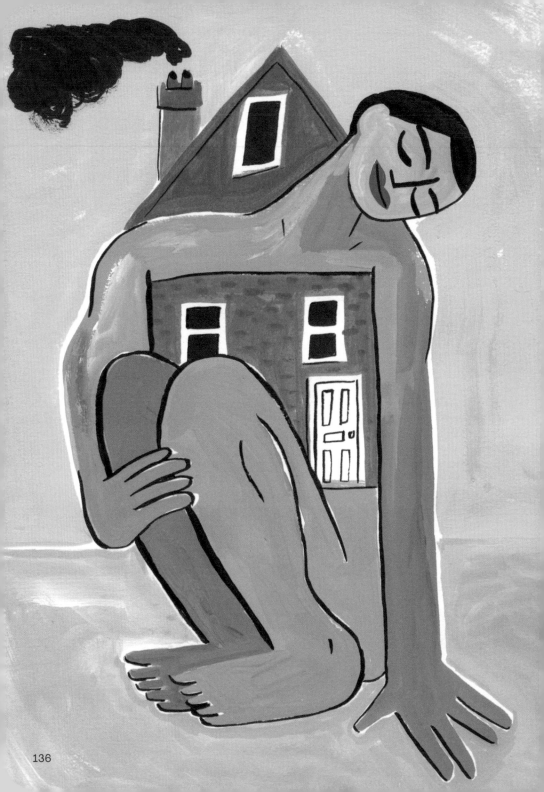

Home is where the 'art' is! This is one of the gorgeous illustrations Jayde created during the peak of the COVID-19 pandemic, encouraging people to stay home and stay safe. Take inspiration from this and draw a larger than life version of yourself, incorporating your home or the landscape you live in.

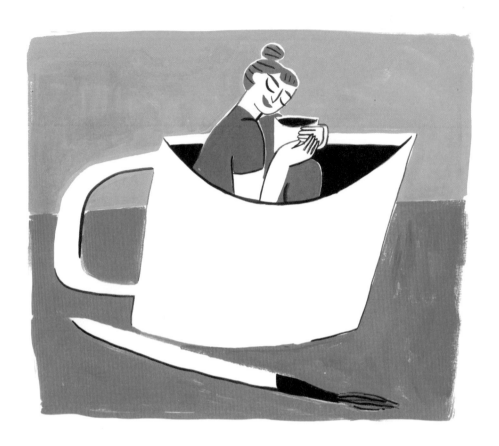

From supersize to XXS! I love the way Jayde illustrates the things she finds comfort in – so soothing and cool! Take inspiration and draw yourself, super-small, inside a mug (cup) or glass.

Illustrations by Jayde Perki

EXPLORE
& EXPRESS

This section is all about exploring and expressing your thoughts, feelings and emotions in a fun and visual way. As well as drawing different expressions and some of the faces you wear in your day-to-day life, you'll be sketching beneath the surface to unlock your true character and voice. From drawing your **#FridayFace** to finding your alter ego, these challenges will help you to create a series of expressive sketches that reflect the TRUE YOU!

How do you look and feel on a Monday? Motivated? Moody? Draw your #**MONDAYFACE** here.

Now show us your #**FRIDAYFACE**! For an extra LOL, draw a super-smiley selfie with your non-dominant hand.

The drawing of the face opposite will be very familiar to my friends and family. It's one of my 'Dulcie faces' (e.g. the face I pull when I'm not very impressed). We all have one, don't we?! Draw yours on this page.

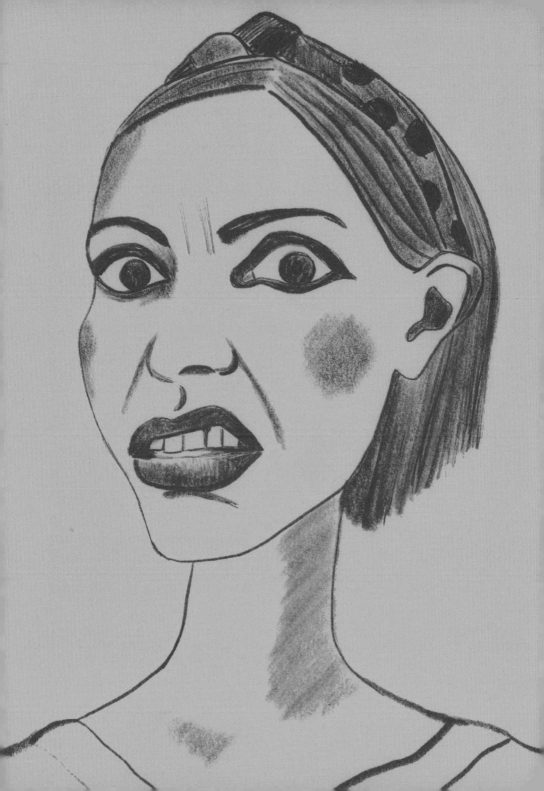

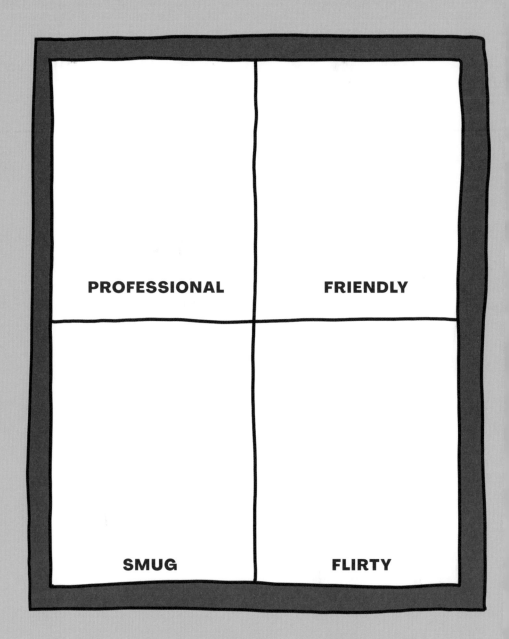

PROFESSIONAL

FRIENDLY

SMUG

FLIRTY

If you engage with social media, you might remember a challenge that involved selecting 4 pictures representing and poking fun at the various faces you put up and put out there. Follow the prompts in the frames and draw your portraits to complete your grid!

CREATE AN ART-VATAR!

Unless we do it professionally, not many of us define ourselves as 'artists' — but we are! Create an avatar of you in 'artist mode', expressing the creative side of your personality. Go classic (beret and striped top) or go wild!

TARA BOOTH

Tara Booth is an Ignatz Award winning comics artist from Philadelphia, PA. Her vibrant gouache paintings are densely coloured and largely autobiographical. She uses humour to explore the intricacies of mental health and addiction. I asked her:

What does self-love mean to you? Loving the ugliest parts of yourself, working to understand and respect your inner child and allowing yourself the opportunity to grow.

How important is creativity to your mental health? Drawing and painting can be meditative and relaxing: it can feel a lot like writing in a journal. When I make a comic about a difficult situation or emotion, tension is released, and when I share my drawings I'm always pleasantly surprised by the number of people who send positive feedback saying they can identify with my work.

How has drawing and making art helped you overcome challenges? I try to be 100 per cent transparent in my drawings, even when the feelings I'm illustrating seem particularly ugly. By being open about my mental health struggles, I've found acceptance in a community of people who understand what I'm going through. I've also found that being open about difficult issues will open the door for conversation and solution sharing.

What's your favourite creative mood booster? I love gouache! Mindlessly painting a pattern on my characters outfit is super relaxing.

Any self-care tips? I love laying in bed and listening to podcasts with a candle lit and a kombucha.

Follow Tara **@tarabooth** on Instagram.

Illustration by Tara Booth

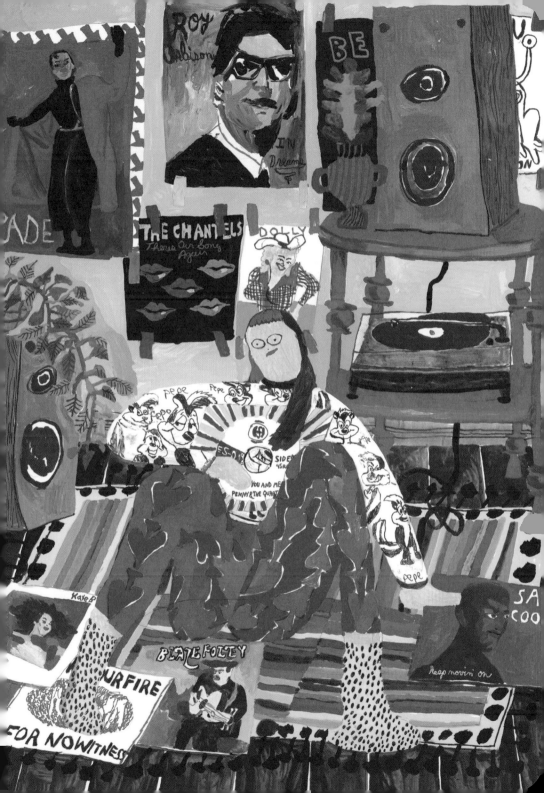

▄▄▶ Take inspiration from Tara's 'Mood Swings' illustration and draw an expressive, animated portrait of you in one of your 'go-to' moods. Look at how Tara combines exaggerated stances, simple facial expressions and a FIERCE outfit to capture both the light and dark side of her mood swings.

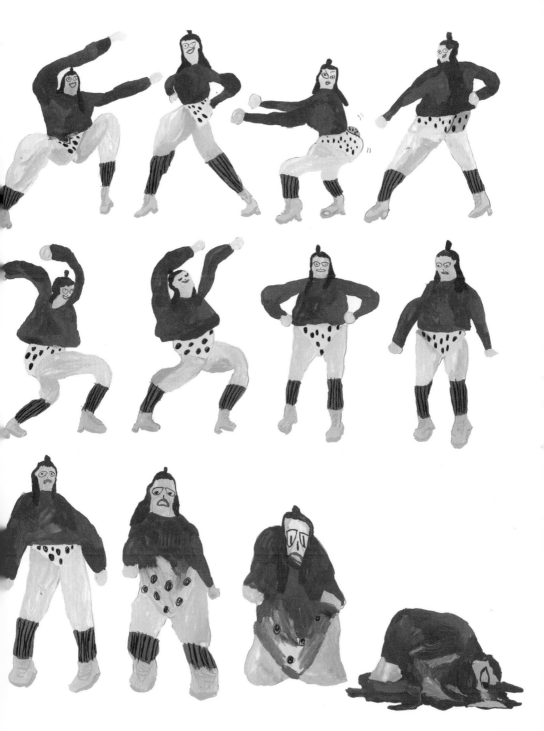

Me to Me:

OKAY, so HAVe I pROVeN thAt I'M "eNOUGH" Yet?

▬▶ We've ALL got a (grown up) public persona that strives and an inner child who just wants to be loved, be fed and be happy! Draw an illustration of you and yours, inspired by this illustration by Tara.

'AS A CHILD, I DREW TO
CREATE AN ESCAPE HATCH
INTO IMAGINARY WORLDS
WHERE I HAD CONTROL.
THIS CHILDHOOD TEMPLATE
OF CREATIVITY STILL
WORKS FOR ME.'

GRAYSON PERRY

SKETCH YOURSELF FREEEEEEEEEE!

Drawing with your non-dominant hand is one of the fastest ways to unlock your inner child and to sketch yourself free from pressure to get it 'right' (and it's a lot of fun!). When you draw in this way it's much harder to control the marks and lines you make, so your mind focuses more intently on what you're drawing, instead of on your drawing itself. You'll also be in a more playful and open space, creatively and emotionally, which makes you more receptive and perceptive. Ultimately, it enables you to draw freely and confidently, with a reassuring caveat in mind – after all, how 'good' can it be if you draw it with your 'wrong' hand?!

Pioneering Art Therapist and Author Dr Lucia Capacchione (PhD) has been championing the power of non-dominant hand drawing for decades. Tests and studies have shown that it:

Forces us to think and be more conscious and engaged in the task at hand.

Opens our minds and eyes to new ways of seeing and expressing ourselves.

Boosts creativity.

More importantly than any of that though, it makes us SMILE!

SITCOM YOUR LIFE!

I love drawing with my non-dominant hand – it frees and lifts me up like nothing else. When the COVID-19 pandemic hit, I started drawing situational self-portraits with my non-dominant hand every day. These loose sketches helped me to explore, ridicule and express my thoughts, feelings and behaviour as the days went by. I've always struggled to draw the 'sitcom of my life', or at least in a way that feels authentically 'me'. With these sketches I drew entirely from my imagination, mind and heart: resulting in a collection of drawings that captured my true voice and character like nothing my dominant hand has ever produced.

Give it a try! Draw an every day occurrence or situation in your life Bored in a meeting? Dancing in your kitchen? Attempting to do a fancy yoga move? Draw it!

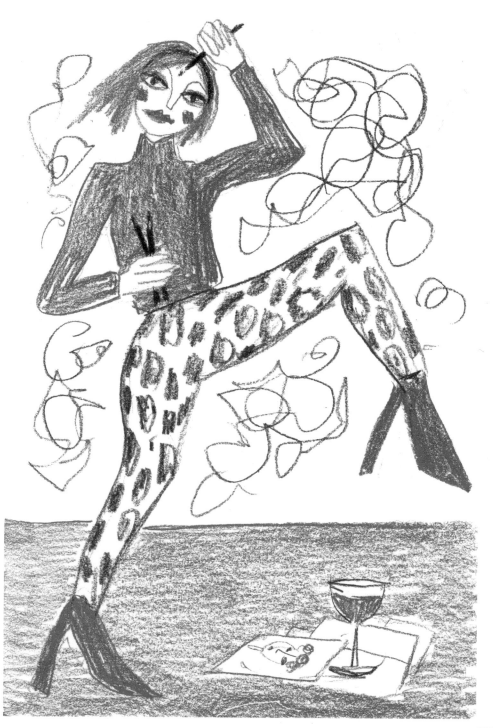

JEMIMA SARA HAND

Jemima Sara Hand promotes freedom of expression and the mental health benefits of drawing through her creative business JEMIMASARA. She believes getting creative is a fundamental human necessity and is fascinated by human behaviour, psychology and using drawing to ignite conversations and release emotion. Her work focuses on human connections and alter ego's whilst challenging stigmas in society. I asked her a few questions.

What does self-love mean to you? It's about self-acceptance. Accepting yourself for the way you are right now. The word 'self-love' has been commercialised, making us think you need something material to make you love yourself. You don't. It is a process and takes practice – it isn't easy. Creativity has enabled me to express my experiences and share my emotions.

How important is creativity to your mental health? As someone who says creativity saved my life, I did a lot of research into it. It can boost happiness, mental health and wellbeing. You don't have to be an artist to benefit from drawing. It is a form of expression and communication where no oral language is required! Drawing helps me with my mental wellbeing and has continued to aid my work in all aspects of life.

How has making art helped you overcome challenges? I started JEMIMASARA out of a recovery process and, at the beginning, I was drawing naked ladies who loved themselves. I called them my 'Martini Ladies'. My love for creativity really began from my exploration and celebration of the female form. For a very long time I felt as if I had no voice and I did not know how to express myself. It can be hard to find words to express what we feel, especially when our mental health isn't at its best. Drawing, scribbling and making art has helped me to find my confidence, my voice, and to start my own business!

What's your favourite creative mood booster? I love a good scribble! My favorite scribble is having my eyes closed and continuously running my pen across a blank piece of paper. I have no idea where the line will take me, but when I open my eyes I have just created some form of me on the paper.

Follow Jemima **@jemimasara** on Instagram.

Illustration by Jemima Sara Hand

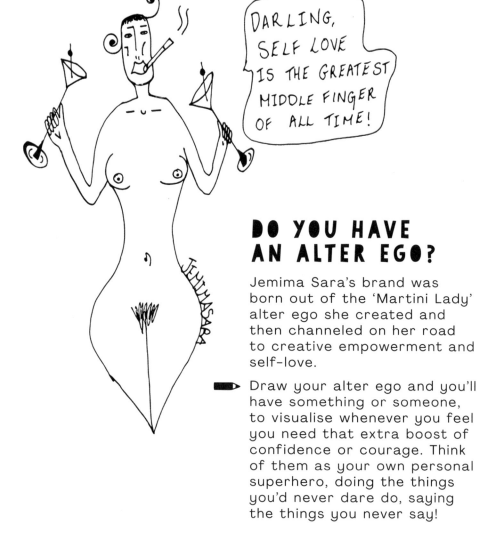

DARLING, SELF LOVE IS THE GREATEST MIDDLE FINGER OF ALL TIME!

DO YOU HAVE AN ALTER EGO?

Jemima Sara's brand was born out of the 'Martini Lady' alter ego she created and then channeled on her road to creative empowerment and self-love.

Draw your alter ego and you'll have something or someone, to visualise whenever you feel you need that extra boost of confidence or courage. Think of them as your own personal superhero, doing the things you'd never dare do, saying the things you never say!

What qualities does your alter ego have? How do they dress? Where do they live? Work? Socialise? Do they have a catchphrase? An exotic accent? A favourite drink? Jot and doodle some ideas down on this page.

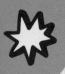

NICOLA FERNANDES

Nicola Fernandes is the powerhouse behind the portraits of the iconic artists in this book. As well as bold and brilliant portraiture, Manchester-based Nicola creates a range of quirky and fun illustrative treats: from art prints to celebrity (wooden) spoons! She also runs events, designed to engage people of all levels and backgrounds, in art. Nicola has a passionate belief in the therapeutic power of creativity, so I was only too excited to work with her on this book! I asked her some questions...

What does self-love mean to you? For me, self-love has grown from being able to express yourself by any means: talking, creating, learning, exercise. I find any activity that allows me to get lost in it really soothes me. Painting has created a world where I can feel safe to express myself and connect with others and heal.

How important is creativity to your mental health? Creativity has been my survival method in maintaining my sanity throughout difficult stages of my life. I have been able to connect with and build communities through making art, and make friends in big cities that used to terrify me.

How has drawing and making art helped you overcome challenges? When I moved to Manchester I had absolutely no friends. I struggled for years to meet people because making friends as an adult is so hard! So I started painting: I made some very ridiculous Louis Theroux and Jeff Goldblum fan art to sell at craft markets, not for the intention of actually selling, but to use art to create meaningful and fun conversations with strangers.

How do you relax and practice self-care? Relaxation for me is getting lost in something very creative like painting where your full concentration is in the mark-making and the composition of your work. I'm very inspired by nature, and going out into the wild is my way of practicing self-care. I love to stay still in very open spaces where I feel very small; for example the in woods surrounded by the sounds of the wind, leaves and birds, or sitting on the beach at night when all you can hear is the waves – it's a very sensory experience.

Follow Nicola **@fernandesmakes** on Instagram.

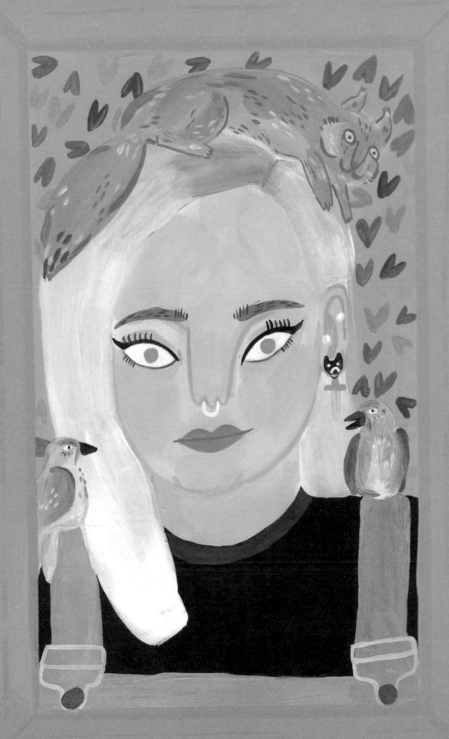

Illustration by Nicola Fernandes

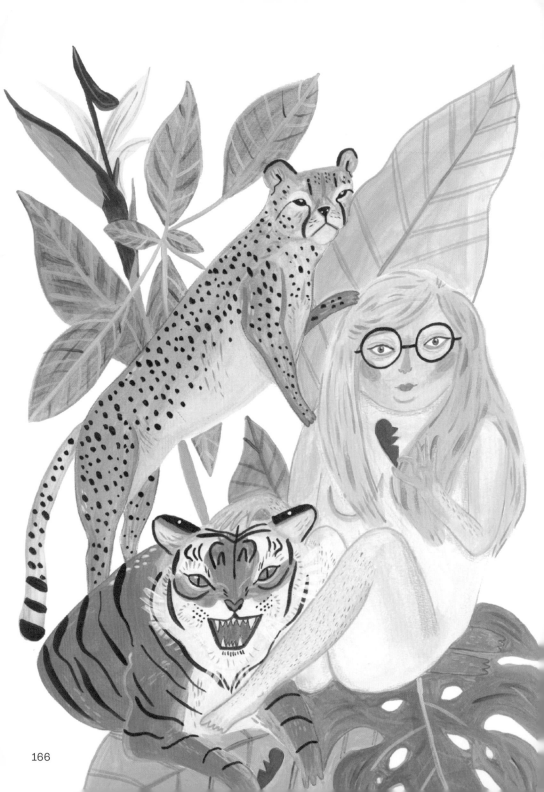

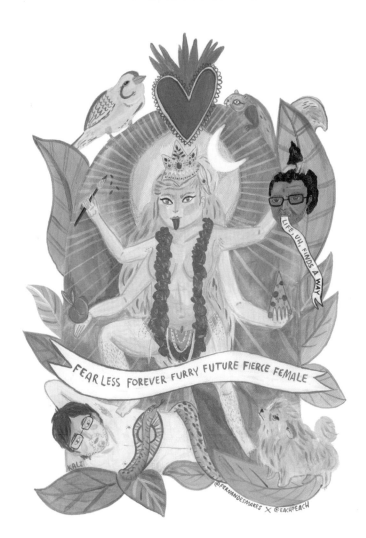

Nicola's 'self-love shrine', encapsulates the humour and feminist undertones that run throughout her work. In a tribute to her Indian heritage, Nicola depicts herself as Goddess Kali – powered by pizza and pinning down Jeff Goldblum with her thighs! She says that the peach represents the nature that nurtures her; the canary the bright fires of home.

What would be in your shrine? Try drawing one incorporating your favourite colour, favourite animal, favourite food, something about your family heritage and something/someone you love. And yourself of course – semi-naked or otherwise!

JUST FOR FUN!

As the title suggests, the challenges in this section are just for fun! These are just a few of the activities I've used at workshops and enjoyed doing over the years. I'd love to see your responses to them!

'SERIOUS ART IS BORN FROM SERIOUS PLAY.'

JULIA CAMERON

REACH FOR THE STARS!

▄▆► Draw a self-portrait inspired by your star sign. You might like to add words highlighting some of your strongest characteristics, incorporate your zodiac symbol (or just shower yourself with stars!).

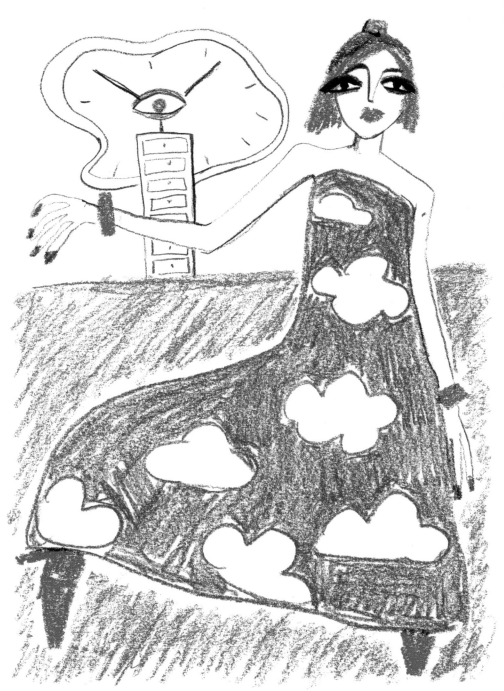

ARTFIT GOALS!

Design a dream 'artfit' inspired by art and creativity!

DREAM DESTINATION

Where would you love to be right now? Take a (full-length) selfie in the mirror and then transport yourself to your dream destination via the magic of your creativity!

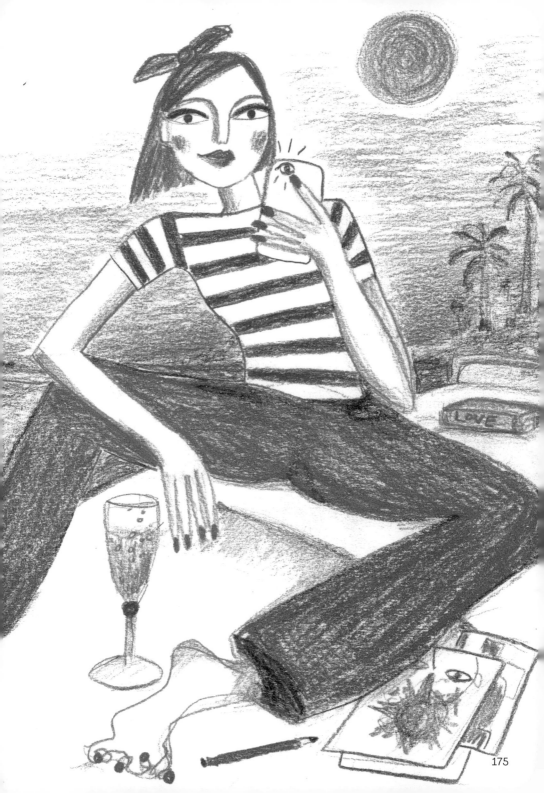

GO WILD!

Draw a self-portrait incorporating as much flora, fauna and animal print as you possibly can!

WES UP!

➤ Draw yourself into one of your favourite films. (Can you guess what mine is?!)

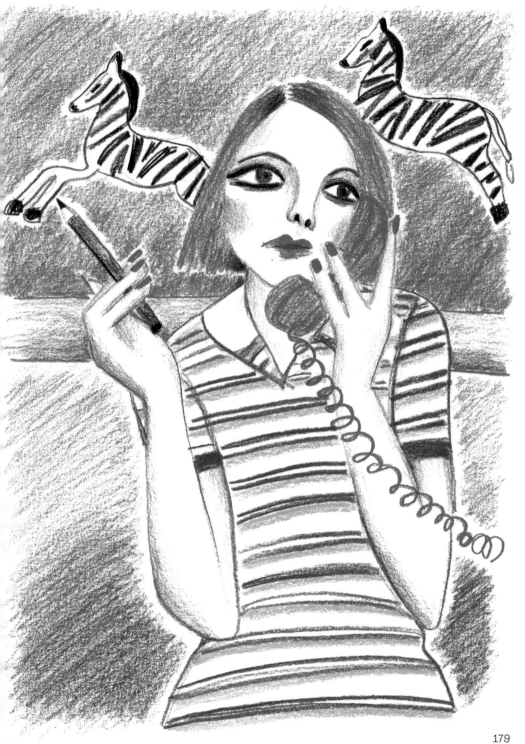

GROOVE IS
IN THE ART

▶ Draw a self-portrait inspired by one of your favourite songs.
Add lyrics and imagery however you see fit. Perhaps look at
the original album artwork and see if you could draw yourself
into it?

FLOWER POWER!

Draw a flower-powered self-portrait packed with serious 60s VIBES!

80S VIBES

Give yourself a rad 80s makeover. Go big and go BOLD! Draw hard and fast to give your portrait extra 80s power vibes!

'SOMETIMES YOU WILL NEVER KNOW THE VALUE OF A MOMENT UNTIL IT BECOMES A MEMORY.'

DOCTOR SEUSS

#THROWBACK!

Drawing from old photos is a great way to recapture some of the energy and magic of the moment that it depicts. I love drawing old photos of me with my friends because it somehow conjures their spirit into the room (which is a magical thing when many of them are miles away!).

Select some old photos of some of your favourite memories and draw them in these frames using only black and grey, to give your pics a gorgeous vintage vibe!

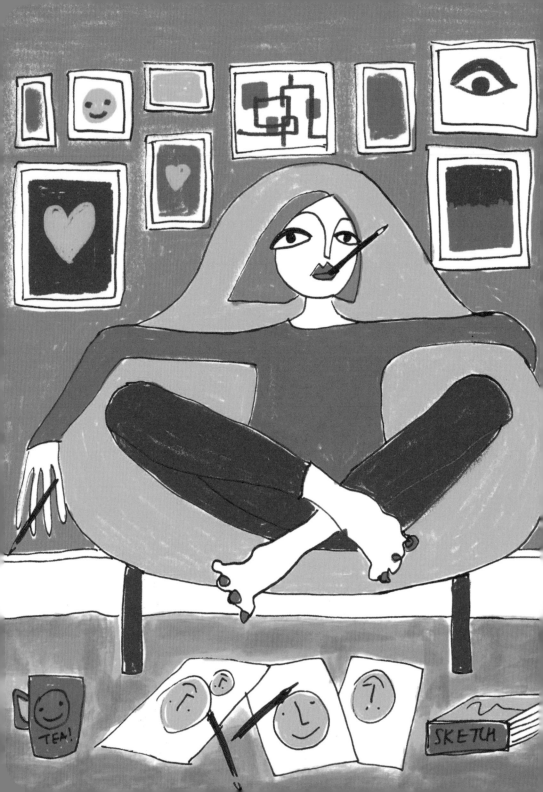

HAPPY PLACE

When someone says 'think of a happy place', what and where immediately springs to mind? Is it somewhere you've been, somewhere you want to go, or a place in your imagination? Where would you love to be alone and feel content, no matter what or who else is in your life? It might be a sun-filled art studio or a cosy living room full of colour and cats! Anywhere that comforts you to think about it — a place your soul would always feel at home.

Sketch out some ideas and be as specific and detailed as you can be: build a clear and vivid picture of where you want to be. The more concrete and clear your vision is, the more likely you are to eventually make your vision a reality! Once you've settled on a vision then draw a colourful illustration of it and stick it up on your wall, somewhere you'll see it every day.

There's a lot to be said for the power of visualisation. If you can dream it and draw it, then you can definitely DO IT!

SELF-CARE

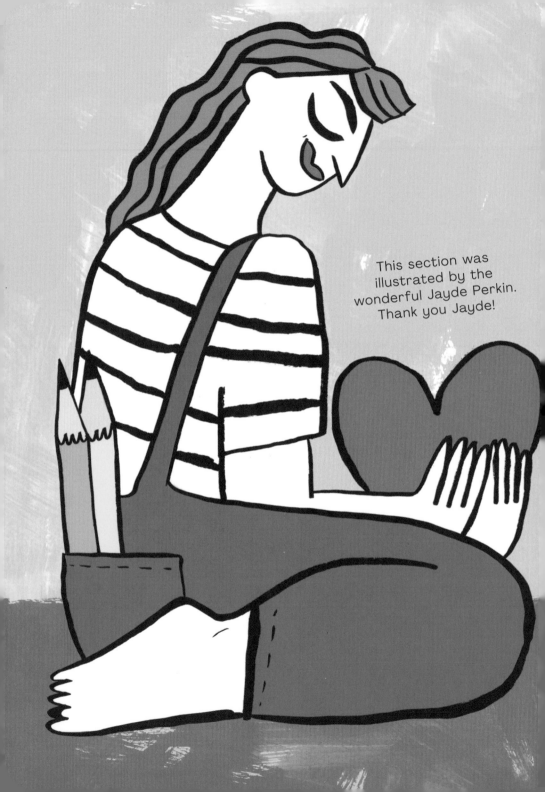

This section was illustrated by the wonderful Jayde Perkin. Thank you Jayde!

TOP 10 SELF-LOVIN' SKETCH HABITS

There's no doubt that getting creative and drawing on a regular basis can have a powerful and positive impact on our mental health. Whatever our level of experience and skill, we can all benefit from enjoying a healthy 'sketchlife'!

In this final section you'll find my top 10 activities and tips for nurturing self-confidence and bringing creativity into your everyday life. Done frequently, these activities could help you to maintain a positive, creative mindset, balance your mood and stay connected; both to yourself, to your creativity and to life! The more you engage your 'artist's eye' the more you will learn to look and live in the moment, and see the beauty of your true self and the world around you.

These activities are my way of practicing self-care and play a huge role in maintaining my mental strength. They remind me to be kind to myself and acknowledge the things I have achieved, instead of focusing on what went 'wrong' or the million things that I haven't yet done. I still struggle with anxiety and low self-esteem, but by making these activities part of my life and daily routine I have definitely learned to believe in myself more. I hope they're useful and beneficial to you too!

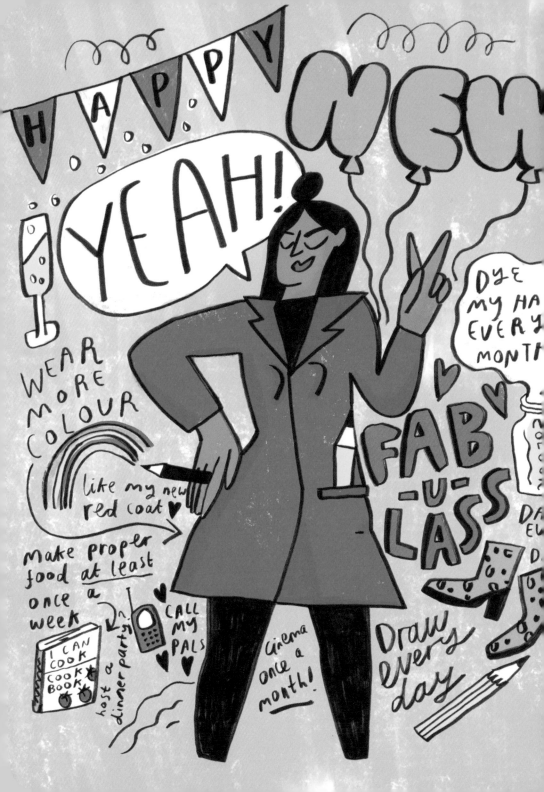

I.
DRAW YOUR GOALS

New Year can be a challenging time for a lot of people, myself included! If you've got a strong and noisy 'inner critic', you probably tend to focus on the things you've done 'wrong', or haven't yet done, instead of all the awesome things that you've totally ROCKED!! This can make us skeptical and weary of setting future goals because we focus on the negative – when in fact there are loads of positives and we are capable of achieving a lot more than we often think we are!

Drawing your New Year goals is a really great way to make them a reality. For the past 4 years I have – like a hermit – stayed in on New Year's Eve and taken time to reflect upon and draw the things I have enjoyed, achieved or loved about the past year. I then define some goals for the year ahead and create an illustration of them on A3 paper, alongside a self-portrait. I try to set a mix of small and bold goals, so that I've got something manageable and something MEGA to aim for! I'm yet to achieve them all, but I've managed quite a lot over the years, and pinning these illustrations up on my wall helps me to stay motivated all year round.

You don't need to wait until January to give this a go, why not try it for the rest of the year?

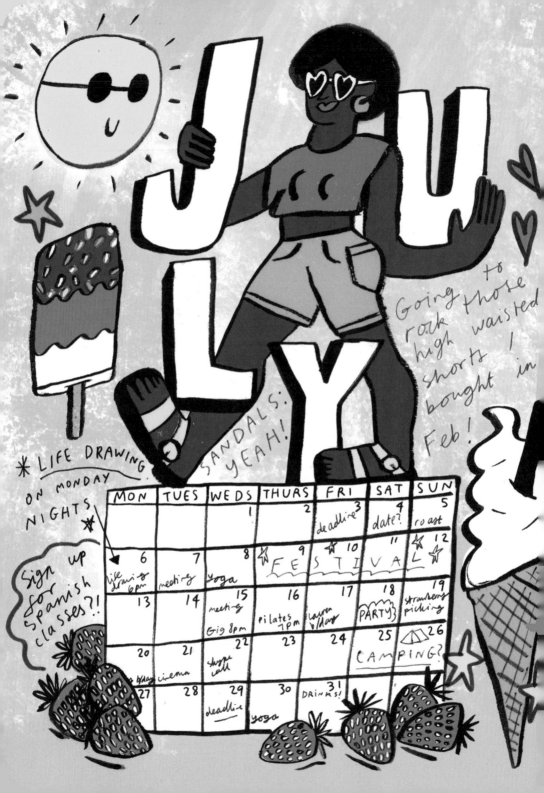

2.
DIY CALENDARS

Drawing your own yearly calendar is a great way to get some guaranteed creative action at least once a month. You can use whatever size you like but I recommend drawing on A4 or A3. Remember to add the name of the month and dates on there too, if you want this calendar to be of practical use. Draw whatever you feel like each month, but I'd highly recommend making your calendar all about YOU!

TIP: Take a full-length selfie in the mirror to draw your 'base' illustration from and then transform yourself and your backdrop as appropriate!

Here are some ideas of things to feature:

· You + specific visual goals for that month (e.g. go life drawing, bake some scones).

· You wearing a cool outfit in keeping with the season (real or fantasy).

· You + things you love or associate with that month (like you + sunshine + strawberries).

· You + a location you'd like to visit that month (e.g. a beach, a park, a chic Parisian café).

· A throwback to one of your favourite selfies or photos from that month in a previous year.

Z I N E S

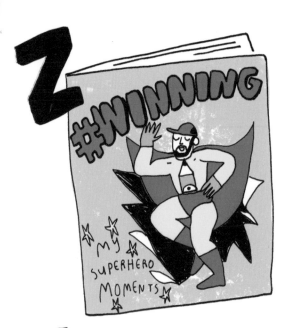

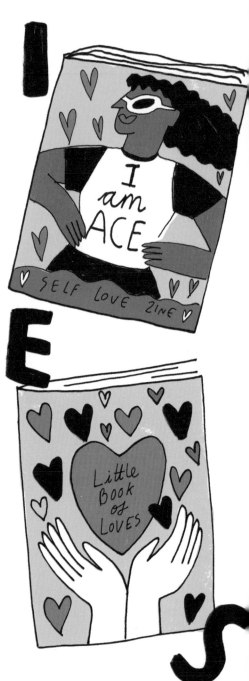

3.
MAKE SOME ZINES

Making zines is such a satisfying creative activity, and there are some brilliant ways you can use them to nurture positivity and self-belief. There's something about the size and simplicity of the format that feels manageable too, and often far less scary than a huge blank page. Each time I make one it feels like a real accomplishment – like creating a mini book!

You could make and use zines in a functional journalistic way, to document your life, thoughts and feelings; or you could use the format in a more creative way, to tell stories and make mini books – maybe even share them with others. Either way, I'd encourage you to make a zine at least once a month, on whatever topic or theme takes your fancy.

See overleaf for instructions and materials you'll need to make your own zine.

Here are some zine ideas:

· A zine about a 'superhero' moment or a favourite memory of your life so far.

· A self-love zine featuring all the things you love about yourself*.

· A self-care zine featuring things you do (or need to do more often!) to take care of yourself.

· A zine featuring some of your favourite things. This could be material things, or you could write about your guilty pleasures, or your sensory pleasures (e.g. your favourite sights, smells, tastes, sounds and things to touch?).

* If you find the idea of this a bit 'cringe', all the more reason to give it a go!

HOW TO MAKE A ZINE

To make an A6 8 page zine you will need: A3 paper, scissors and whatever drawing materials you like to use. Follow the steps below to assemble your zine.

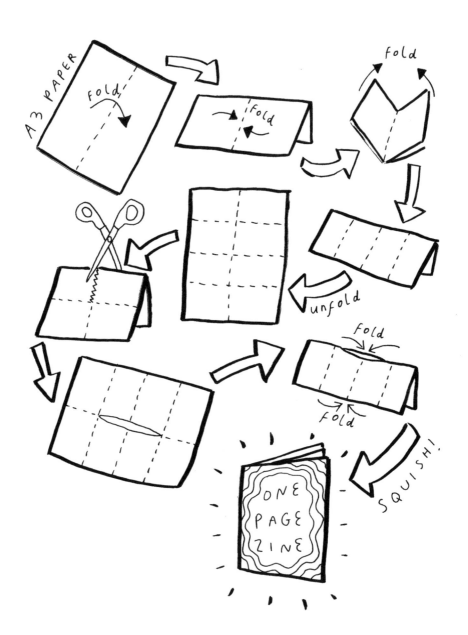

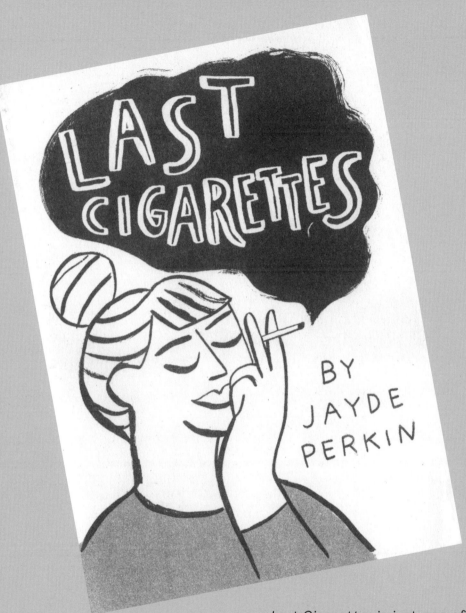

Last Cigarettes is just one of Jayde's fab autobiographical zines. Do you have any habits or behavioural patterns that could be interesting to explore through zine-making?

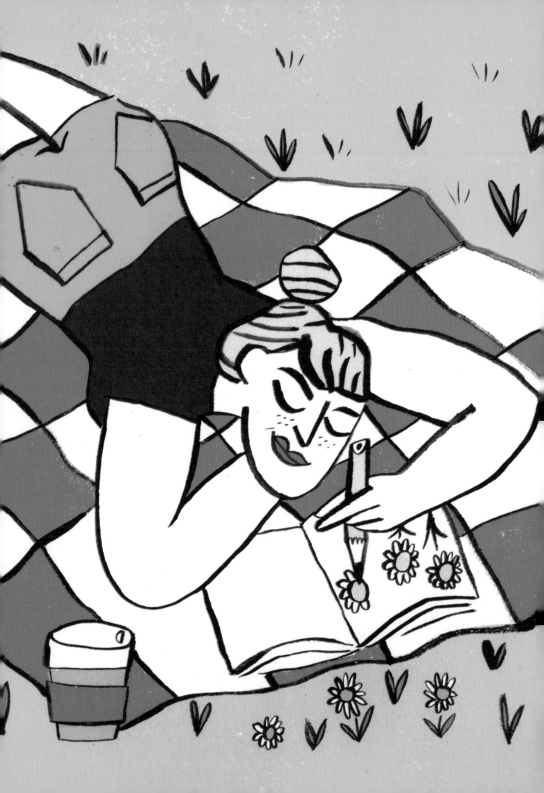

4.
DRAW YOUR DAYS

Reflecting on life is more important than reflecting on ourselves in the mirror. Drawing your day is a great way to sharpen your observation skills and a brilliant way to keep your creativity switched on at all times. It can help us to live our lives in a more conscious way, which can bring us great insights into our lives *and* into the world around us. If you struggle with anxiety and spend a lot of time in your head, documenting your days is a great way to be present and grounded in reality, and to appreciate all that you are and have.

You could keep a sketchbook and just draw the things that capture your attention as you go, or take pictures and draw them at home. But if you need a more specific goal, try setting yourself one of these week-long sketch missions!

WEEKLY ZINE MISSIONS

On a Sunday evening, pick a theme and decide what you're going to keep your 'artist's eye' out for over the week ahead. Something in every colour of the rainbow? Unusual packaging or labels? Things that make you laugh or smile? People wearing colour or unusual clothes? Different patterns?

'Hunt' and photograph things throughout the week and then set aside some time to make a zine featuring them. This is a great challenge for a Sunday afternoon when you're winding down and have a bit more headspace. THE perfect time to reflect!

Set yourself these missions on a regular basis and you should find yourself spending less time glued to your smartphone and more time looking up at the world around you, IRL. RESULT!!

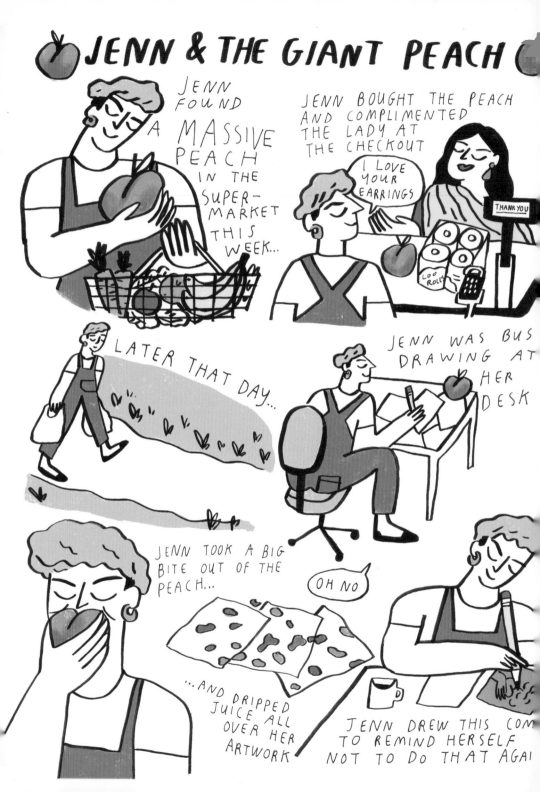

5.
STRIP OFF!

Make a comic strip about a moment, day or week in your life. Think back to something funny or fabulous or mundane that has happened over the past week or month. Did you have a 'superhero' moment or overcome a challenge? Did you accomplish something small or spectacular? Or did you just drink loads of coffee and go to work as usual? I challenge you to make light of a situation or event in your life and make a comic strip about it. You could develop a whole character for yourself, draw yourself wearing a special outfit, give your comic strip a name. This is another great challenge if you're in need of a laugh, and a great way to unleash your inner artist!!

You can use whatever form of a comic strip you like: a short and sweet triptych or something bigger and Beano-style, like the strip on the page opposite. You could even start and fill an entire sketchbook with your comic strip and keep the adventures going!

6.
WORD UP

We've all got favourite phrases and quotes that motivate and inspire us. Some of us might even have personal mantras or affirmations. Social media is awash with #**INSPIRINGQUOTES** reminding us to 'keep going', and they can be great little mood boosters if we're feeling a bit low. But these statements can empower us on a much greater level if we take some time to draw them. The more time you spend pondering and drawing out the words, the more you will start to remember and live by them.

NOTES TO SELF

Illustrate one of your favourite statements on an A6 or A5 piece of card/thick paper. It could be a famous quote, a positive mantra or just a phrase you love. It doesn't matter if it's offensive, sentimental or intellectual: just pick whatever means something to you and will make you feel good, amused or empowered. Pin it up on your wall or better still, why not write a note on the back and then send it to yourself in the post?! You'll thank yourself for it later, literally :)

SHARE THE LOVE

Repeat as above, but send a your 'postcard of positivity' to a friend instead. It's such a fun and simple act of kindness and way to show you care about someone, and I bet you, it'll make their day!
This is such a sweet way to send love and share the 'joy of sketch' with others!

7.
SUNDAY NIGHT SELFIES!

Sunday night is the perfect time to let your inner child/artist out to play, before all that 'adulting' you've got to do in the week ahead. Like a lot of people, I'm susceptible to the Sunday night blues, but incorporating this silly selfie challenge into my weekly routine really helps to distract me from them.

Every Sunday, I take a selfie and draw it with my non-dominant hand, adding whatever caption or words of motivation I feel like at the time. The end result is always a bit wild and wonky, and a great reminder not to take myself or life too seriously!

This is such a fast and fun little 'sketchercise' to fit into your weekly routine. Give it a try and see if it works for you! If you do, I'd love to see your silly selfies over on **@SketchAppeal**.

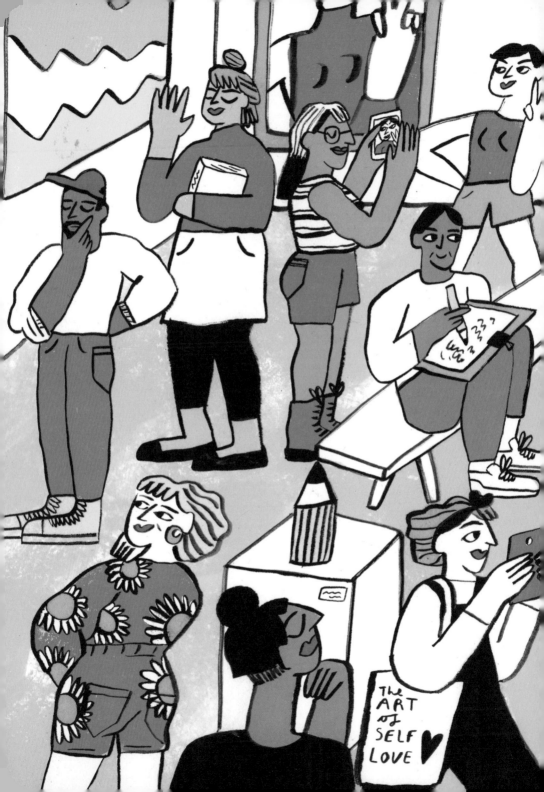

8.
'SKETCHDATE'
YOURSELF

At least once a month, set aside half a day or a couple of hours to go some place and draw. You could visit a gallery or an exhibition, sit and sketch outdoors, or simply go sit in your favourite café and sketch the things and people that surround you. There are no rules to 'sketchdating', but try doing it alone so you don't get distracted or have to think about anything but your own creativity and needs.

Whenever I visit a gallery and draw alone like this it feels like a mini holiday. These 'sketchdates' give me permission to pause, ponder and absorb life, instead of stressing about all the things that get in the way of it. There's something really nourishing and comforting about being enshrouded by art, sketching in (relative) silence and feeling like I could be anyone, any age, anywhere in the world. I love drawing at home on my bed to relax, but it's only when I go on these little 'art-ventures' that I'm able to get fully out of my head and feel a true sense of freedom and respite.

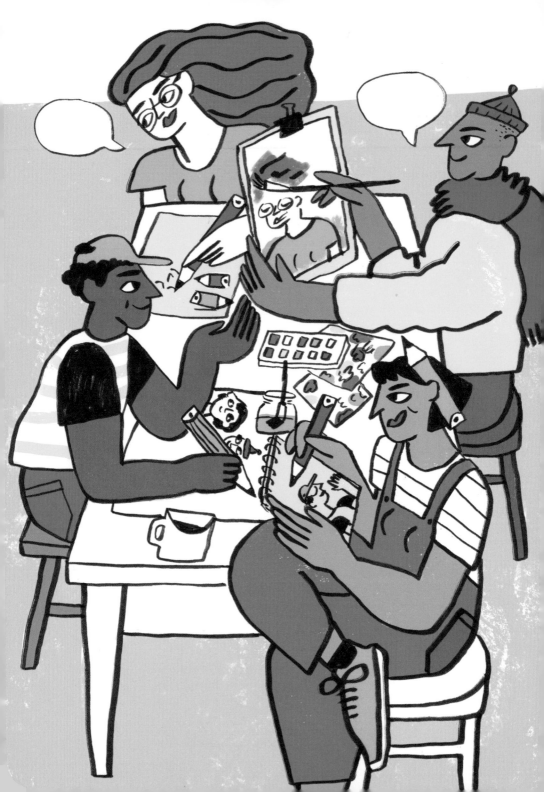

9. MEET+PLAY+DRAW!

There are loads of life drawing classes and social sketching events out there these days – go check them out! There are tons of online offerings too. Sketching alongside others is great fun, and fantastic way to connect and make friends with likeminded people. It can be a challenge if you're feeling anxious or knackered, but push through it and I guarantee you won't regret it!

I run lots of social sketching events and workshops in London and get to see the social power of art in action all the time. I have the joy of watching people connect as they explore and share their creativity; empowering, encouraging and inspiring one another as they draw. I see trust and empathy build, and observe confidence grow as the activities break through their social and creative barriers and they remember how much fun it is to PLAY!

I run a portrait-sketching club called 'Sketchy B*tches' and it's one of the best things in my life ever! I've met some awesome friends through it and seen others do the same. We meet and talk as adults. but we play and draw like kids without a care in the world! It's a joy to draw alone but it's a delight to play and draw with others too.
So get ART there!

10.
SCRIBBLE TO
THE BEAT!

This is one of my favourite warm-up games and a great little mood booster for those times when you can't be bothered to draw anything in particular – or anything at all!

Pick one of your favourite songs – ideally one with a strong beat – press play and then simply scribble to the beat of it, until the song ends or until you run out of room on your paper. Don't try and draw anything specific or take it too seriously. This is an 'ART tracing' not a 'heart tracing'! Just let the music move you and imagine you are 'Doctor Beat' – checking and sketching the pulse of a song!

I'm yet to do it, but one day I will try and draw an entire album in one sitting and have myself a little drawing disco... 'Sargeant PAPER' perhaps!

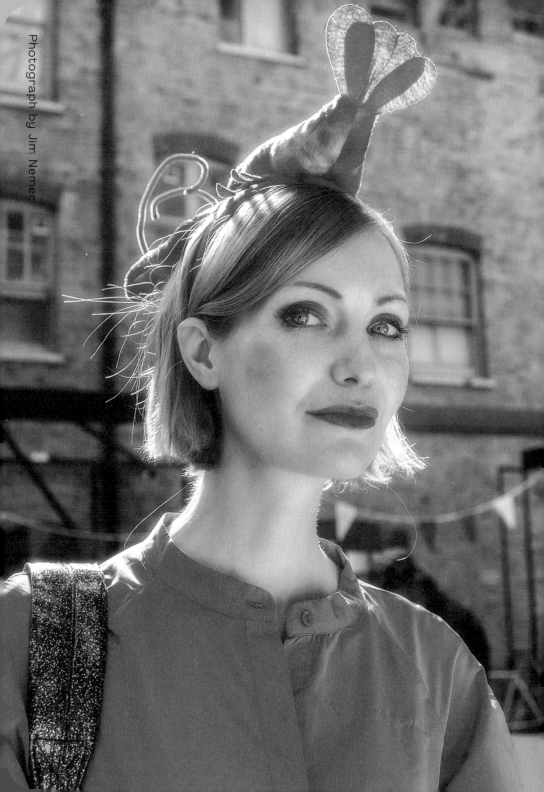

ABOUT
THE AUTHOR

Dulcie Ball is an Artist, Creative Facilitator, and the Founder of Sketch Appeal CIC; a London-based Community Interest Company which advocates the mental health benefits of drawing and the 'joy of sketch'. She leads their social sketching events across London and online, as well as various wellbeing and community arts projects, including courses on *The Art of Self-Love*.

Dulcie grew up on a farm in East Yorkshire, in a creative family who encouraged her love of drawing, dancing, and playing the piano. In 1999 Dulcie got an A in A level Art, but decided she should get a 'proper' degree and job, so she went on to pursue other things; a degree in Spanish followed by a 15 year career in marketing, working across the Arts, Publishing and Charity sectors. She loved it, but she didn't love herself much back then, and it wasn't until she rediscovered her love of drawing in 2016 that this all started to change. She credits that moment as being the catalyst for her recovery from anorexia and her rediscovery of LIFE. Dulcie was so inspired and empowered by her experience that in 2018 she launched Sketch Appeal and self-published a magazine of the same name. That magazine landed up on the desk of Hardie Grant Books and the rest, as they say, is *her*story!

Aside from drawing, Dulcie's greatest loves in life are writing, dancing, cycling and yoga — she also loves a good scone! Above all, she loves her friends, her family and all the incredible people who form part of the Sketch Appeal community.

Follow her **@dulcimerball** and **@sketchappeal**

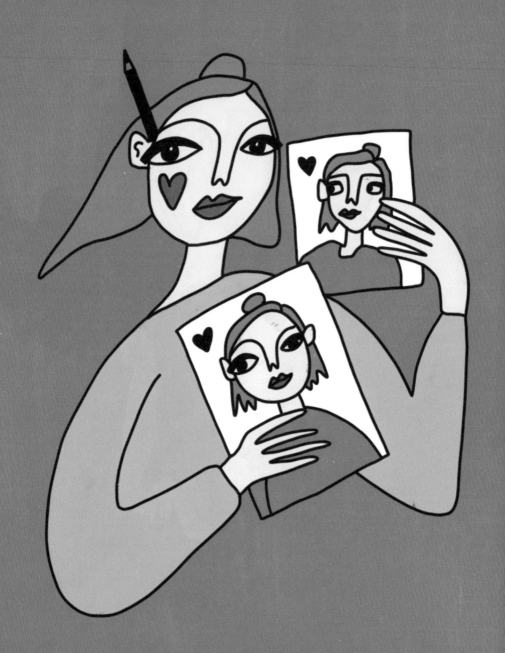

JOIN SKETCHY BITCHES!

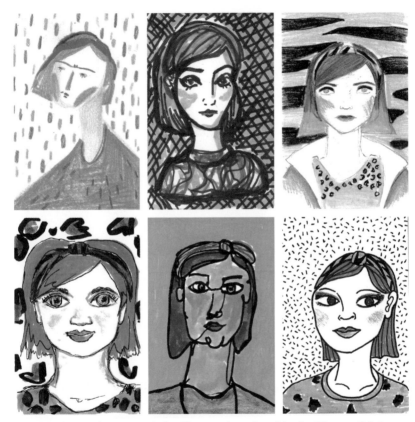

Clockwise from top left, illustrations by: Cincin Chang, Olivia Carlin, Charlotte Davy, Sarah Fox, Rae Jenkin, Sara Hughes

These miniature portraits (of me) were created by members of Sketchy Bitches, the portrait club I run in London and online. We hold informal interactive sessions where everyone gets chance to draw and pose for their portrait, whilst enjoying plenty of music and chat along the way. With the focus on play over 'perfection', this is an opportunity to experiment and express yourself in a relaxed and supportive environment. Sketchy Bitches is a fast-growing community full of lovely like minds – from beginners to pros, we welcome you all!

Wherever you are in the world, check **@sketchappeal** on Instagram and come draw with us online!

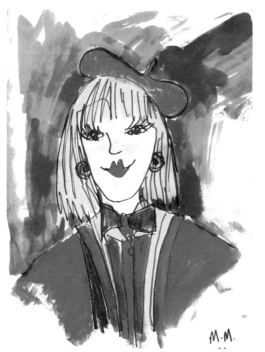
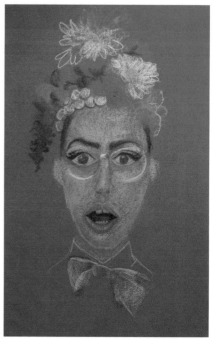
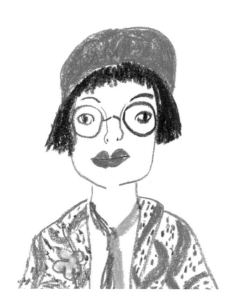
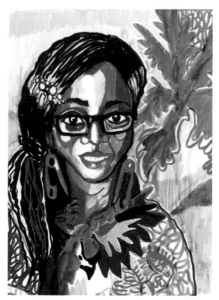

Clockwise from top left, illustrations by: Megan Metcalf, Veronique Truffaut, Nikki Shaill, Alberta Torres. Page opposite: Becky Cole

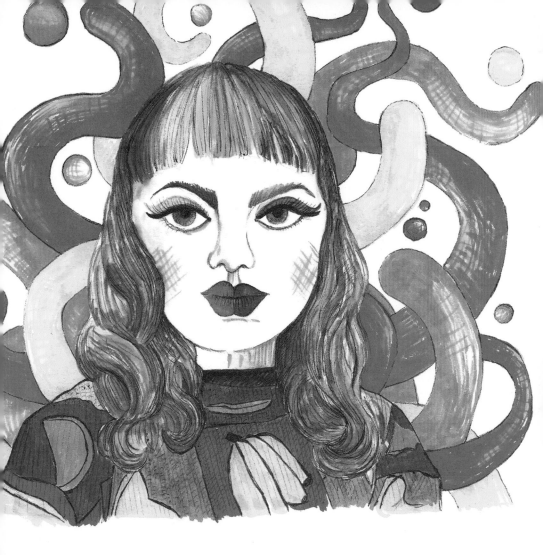

#SKETCHTHERAINBOW

These are just some of the wonderful portraits generated by a recent #SketchTheRainbow portrait challenge I ran over @sketchappeal on Instagram! We invited Sue Kreitzman and some of her fellow London Colour Walkers to be our muses for the week, and the results were nothing short of SPECTACULAR! Taking part in this or any other colourful Instagram challenge is a great way to boost your confidence in sketching the rainbow!

We run this challenge twice a year — follow @sketchappeal on Instagram to join in with the next.

First and foremost, HUGE THANKS to Han and Kajal,
without whom this book wouldn't exist!

And a massive heartfelt thanks to; Nicola Fernandes and Jayde Perkin,
for their fab illustrations and for being dream collaborators to work
with; the other wonderful artists featured: Tara Booth, Hollie Foskett,
Maria Ines-Gul, Sue Kreitzman and Jemima Sara; Eddie, Emily, Sarah
and my GCSE art buddy Gemma for being my rocks and for believing
I could do it even when I didn't. Ditto to my Secret Agent Dylan;
Andrea, Gordon, Eve and Jo, for your support wit and
wisdom, and everything you've empowered me to be; Mum, Dad
and my beloved Nenna, whose enthusiasm and love I can still feel, and
whom I know would have been more excited than anyone to get her
hands on this book!

Lastly, BIG LOVE and thanks to Sara, Sophie and all the
brilliant Sketchy Bitches!

Published in 2020 by Hardie Grant Books,
an imprint of Hardie Grant Publishing

Hardie Grant Books (London)
5th & 6th Floors
52–54 Southwark Street
London SE1 1UN

Hardie Grant Books (Melbourne)
Building 1, 658 Church Street
Richmond, Victoria 3121

hardiegrantbooks.com

British Library Cataloguing-in-Publication Data. A catalogue record for this book is
available from the British Library.

Sketch Appeal: The Art of Self-Love
ISBN: 978-1-78488-353-9

10 9 8 7 6 5 4 3 2 1

Publishing Director: Kate Pollard
Commissioning Editor: Kajal Mistry
Design and Art Direction: Han Valentine

Colour reproduction by p2d
Printed and bound in China by Leo Paper Products Ltd.